Image Spring Press
10 South Pennsylvania Avenue
Suite 209
Morrisville, Pennsylvania 19067

ISBN 0-9741522-0-X

1. Art 2. Sculpture 3. Photography 4. Art Education

FACING SCULPTURE

a PORTFOLIO of *Portraits, Sculpture and Related Ideas*

Ricardo Barros

by

Ricardo Barros

WITH INTRODUCTION BY NICK CAPASSO

PREFACE

DO NOT BE FOOLED BY THIS BOOK. IT IS PARTLY ABOUT SCULPTURE, ALTHOUGH people who are experts in the field may be surprised by my approach to this subject. It is also a book partly about photography. I display my images as singular works, yet many collectors are drawn to them independent of any sculptural reference and need to know little about whom I've portrayed. But the whole of this book is not bounded by the perimeters of these two categories. The realms of sculpture and of photography are shallows in an ocean of expressive media; this book passes through their territory like a net through water.

This is a book about responding to Art. It is a book about empowerment of the individual spirit. It is about expression of identity as well as unexpected adventure. It is about people who dare to be themselves. And here is something that this book is not: It is not a conventional anthology. Familiarity with sculpture or with these particular artists is not a prerequisite to appreciating this book.

The sculptors on the following pages are interesting people who do interesting work. I met most of them for the first time on the day of their portrait. I made my photograph in response to our personal interaction, to their work, and to the coincidences of that particular day.

My initial reaction to these photographs was one of surprise – the portraits had an unintended quirkiness – and the sessions that brought out this quality were so enjoyable that it was easy for me to nurture the process. I was surprised again when my portraits were displayed in public. Not only did viewers respond to images of 'strangers,' but many also wanted to know more information about each individual. While it was my imagery that sparked viewers to comment, it was their insight that revealed to me how much I still had to learn from the experience. This book is an outgrowth of my response to their questions.

Among those early viewers, Nick Capasso, Curator at the DeCordova Museum and Sculpture Park, was an enthusiastic supporter. He intuitively understood my purpose upon first sight of my portfolio. Nick quickly became a primary source of referrals for many of the sculptors I met. In his Introduction, he provides a larger context for this work by using my portraits as a window onto contemporary sculpture.

You hold in your hands an invitation to look with your own eyes and truly see for yourself. This is exactly what each of these sculptors did to produce their work. It is what I tried to do in making my photographs. And it is what I hope you will do when you look at the following pages.

Ricardo Barros

i want somebody who

 can hold my interest

 hold it and never let it fall

 somebody who can flatten me

 with a kiss that hits like a fist

 or a sentence that stops me

 like a brick wall

 …

 make me go

 WHAT did you just say?

Ani DiFranco

CONTENTS

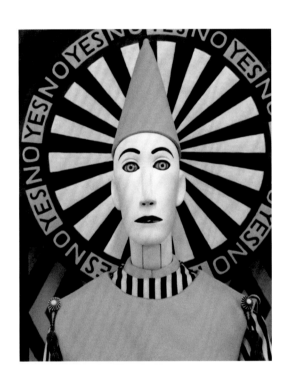

The Answer Man, 1995
by Pat Keck.
Painted wood, mixed media
79 x 18 x 20"

INTRODUCTION

Nick Capasso

I FIRST MET RICARDO BARROS ON AUGUST 4, 1999, WHEN HE CAME TO THE DeCordova Museum and Sculpture Park to show my colleague Rachel Rosenfield Lafo and me, his recent body of photographic portraits. We had not known Ricardo or his work prior to this visit, but our curiosity was piqued by his subject matter, contemporary sculptors. This was a community we knew well; our combined experience with modern and contemporary outdoor sculpture exceeded, at that point, twenty-five years. Our interest was also sharpened because Ricardo had mentioned the names of some of his sitters over the telephone, and we knew many of them personally. I was most impressed by what we saw that day. Ricardo's photographs were imaginative and engaging, carefully composed, formally rewarding, and masterfully printed. The portraits of sculptors with whom I had worked closely were both psychologically honest and complex, and the images of artists whom I knew only by reputation, or knew not at all, were immediately intriguing. These photographs instilled a desire to meet these sculptors, and to see their work.

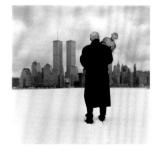

Vladimir Kanevsky

Ricardo's range of subjects also reflected the considerable range of sculptural practice at the onset of the twenty-first century. One hundred years ago, the art of sculpture circumscribed a fairly limited set of materials, techniques, and ideas. Sculpture was, by and large, statuary – representations or idealizations of human figures, wrought in stone or bronze. Statues were meant to be honorific, commemorative, or decorative, and were placed upon pedestals (to remove them physically and psychologically from the mundane) or directly engaged with archi-

tecture. Not so today. Early twentieth-century Modernism and late twentieth-century Post-Modernism have radically expanded the aesthetic possibilities for sculpture. The stuff of sculpture today includes all manner of materials that range from traditional stone, bronze, and wood to modern metals and plastics, to high-tech computers, video, and holograms. Sculpture need no longer vainly attempt permanence, it can now be as ephemeral as dust, gossamer threads, or drops of water. Or, it can have no material substance at all, existing only as pure light or sound. The age-old techniques of carving and modeling, while still practiced, have been supplemented by technical practices more akin to construction, industrial fabrication, or set design. Styles range from the most naturalistic figuration and representation to the abstract and completely non-objective, from the obdurate and the inert to the temporal and the kinetic, from the single object of contemplation to rooms and landscapes transformed by objects into places of transporting experience.

I was also taken by the integrity of Ricardo's portfolio as a whole. He had intentionally set out not to make saleable images of recognized blue-chip art stars, but to communicate something substantial and honest about the broader contemporary sculpture community. Yes, pictures of Big Names were included, but they appeared alongside equally sensitive portraits of lesser-known personalities who operate outside the crushing gravitation of the New York Art Scene. This approach appealed to me because I know well that committed sculptors create excellent work coast-to-coast, and that the few talents blessed by Chelsea, the *Whitney Biennials*, and *ArtForum* represent the mere tip of a much greater iceberg. My experience at DeCordova, where indoor exhibitions are devoted primarily to New England artists and the outdoor Sculpture Park is a nation-wide program, has made me acutely aware of issues surrounding the politics and economics of regionality: marginalization, fashion, celebrity, marketing, and the cultural xenophobia of Gotham's art establishment. By temperament and experience I found myself in sympathy with Ricardo's wide and inclusive lens.

Sensing my enthusiasm, Ricardo invited me to participate in his project by recommending to him "interesting" sculptors from New England who might be willing to be photographed. Although he had already made portraits of over fifty sculptors, he intended to add substantially to the portfolio by ranging far and wide from his Mid-Atlantic base. He had already received referrals from sources as diverse as Grounds For Sculpture, a major venue for contemporary work, and the National Sculpture Society, a venerable survivor of the Beaux-Arts era that represents the interests of the most traditional figurative sculptors. This told me that his tastes were truly catholic, and that he was in no way fooling around. So, I gladly agreed to help, and provided him with a short list of twelve artists whose work, personalities, and personas I knew well.

I sought to match his intentions for the project, and suggested sculptors both emerging and established, well known and obscure, and stylistically diverse. Some work with bronze, others with recycled garbage. Some create monumental works of public art, others craft intricate gadgetry. What unites these sculptors is their commitment to the integrity of their work, and the aesthetic excellence of their sculpture. And, frankly, they are a bunch of quirky characters who, I felt, would be happy to be photographed, and who would make for "interesting" portrait subjects. Apparently Ricardo agreed, for he contacted and photographed these sculptors in short order, and then requested more referrals. All told, I suggested over fifty artists. All were contacted, most were photographed, and twenty-three appear in this book.

Ricardo Barros' portraits of contemporary sculptors must be understood as works of art, not as visual documents vainly striving for objectivity. They are sensitive, personal meditations, worlds away from the market-driven image-consciousness that repeatedly puts forth the posturing of celebrity artists. Ricardo's photographs result from a creative approach to portraiture dependent upon the web of complex relationships among Ricardo, the sculptor, the sculptor's work, and the

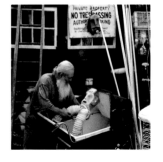

Konstantin Simun

3

work of the photographer. His process is based neither on an imposition of pre-conceptions, nor an overlay of ego, but on a sensitive, intuitive collaboration that yields a wide variety of images. Ricardo's portraits are unconstrained by a "style" or "look." They are individual artworks that reveal an open and honest regard for sculptors, and a desire to construct poetic images. The best of these photographs draw forth aspects of the sculptors' personalities that most closely inform their work, the psychological space between sculptor and sculpture.

The portraits in *Facing Sculpture* tend to fall into several distinct categories, which do sometimes overlap within individual photographs. Many show sculptors at work, or in their studios, where Ricardo concentrates on aspects of the creative process to reveal the idiosyncrasies of the practice of contemporary sculpture. Some sculptors work alone while others work with assistants. Some work indoors, some outdoors. Some studios are neat and tidy, and others are jammed with machines and materials. The foursquare narrative portraits of Arthur Ganson and John Hock pose extreme contrasts in toil and contemplation. Ganson, a kinetic sculptor whose work relies on the precise engineering of tiny moving parts, sits at a table surrounded by gears and wires as he peers into the heart of a machine. Everything is cramped and intimate and messy. Ricardo's photographic composition metaphorically echoes Ganson's intensity of focus and the complexity of the technical problem he faces (and ultimately resolves). Hock works outdoors to create colossal abstract sculptures with giant plates of steel. While Ganson works with tweezers, Hock works with cranes and gantries, and his process is slow and cumbersome. To see his work and solve his problems, Hock must step away, not squint closely. This alternating sequence of labor and reflection plays out among several portraits. Tova Beck Friedman actively draws, while Meredith Bergmann re-examines the gestural relationships between her drawing and sculpture (while the portrait introduces the sculptor's own anatomy and gestures into the formal dialogue). Mags Harries, Lajos Héder, and their crew are hard at work, in a whirl of activity

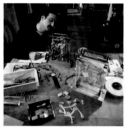

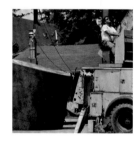

Arthur Ganson

John Hock

emphasized by the spiral shape of the sculpture in process and the spiraling photographic composition. A pensive Robert Ressler, surrounded by stumps, seems stumped.

Other artists appear in the landscape, especially when the outdoors is germane to their work. In these portraits in particular it becomes increasingly clear how Ricardo melds sculptor, sculpture, and photograph – even when artworks are not depicted at all. Carlos Dorrien, a carver best known for abstracted stone figures, stands in profile on the grounds of his outdoor Vermont studio, in pointed proximity to a standing chunk of New England granite that has been a significant source of inspiration for him. Bill Botzow, another Vermonter, is a very tall man whose site-specific outdoor works, fabricated from trees and branches, tend towards elongation and attenuation. And the repeat portrait of Peter Stempel in a grassy meadow reflects the playfulness, seriality, horizontality, and engagement with landscape so important to his work. A straightforward depiction of Stempel could never adequately suggest the particularities of his sculpture: Stempel is a giant of a man, his physiognomy looming, vertical, and monolithic.

Still other artists chose to associate themselves closely with their own finished products, and this direct juxtaposition speaks tellingly of both artist and artwork as objects become extensions of personality and temperament. Ming Fay averts his eyes from the camera, a gesture of humility paralleled by the gentle deference that his work shows to nature. Annee Spileos Scott, in contrast, is gripped by emotion as she stands within her multi-media installation that deals with an episode from political and personal history: the massacre of Greeks by Turks in Smyrna in 1922. Her mourning and keening are accentuated by Ricardo's camera motion and expressive lighting. The late George Segal sits alone, in the corner of a couch, dwarfed by his drawings. These drawings, one of his last bodies of work, echo the loneliness and alienation of his renowned figurative sculpture, and also reflect the state of mind of an artist in the twilight of life.

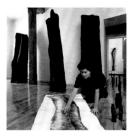

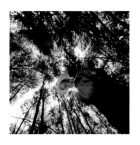

Tova Beck-Friedman

Bill Botzow

Annee Spileos-Scott

Perhaps the most heartfelt images in this book are the portraits of sculptors in direct physical contact with their creations. In several instances, the collaboration between photographer and sculptor resulted in narratives of affection in which the art object is treated like a living child. Vladimir Kanevsky carrying his naked sculpture across the snow, Joan Danziger playing with her sculpture in the forest, Charles Wells pulling his sculpture in a child's wagon, and Konstantin Simun tenderly lifting his sculpture from a baby carriage all speak plainly of the love involved in art making. They also call to mind Pygmalion and Frankenstein, myths that address the profound psychological and spiritual complexities of the creative act. In other instances, the artist's identification with his or her work is even more intimate. Caroline Gibson pulls her mask to her face; Joseph Acquah merges with his sculpture. Art becomes alter ego.

Ricardo's most radically constructed portraits are those in which substantial formal aspects of the photograph are directly informed by particular working methods of the sculptor depicted. Chakaia Booker's work - as well as the way in which she clothes herself - are dependent on collaged layers of thick material. Here she appears engulfed by texture and mass. Niki Ketchman, whose steel sculptures are linear drawings in space, seems scribbled into existence, and Rico Eastman is presented as just another cubistic shard in his abstract sculpture of stacked and interlocked steel plates. Eastman is forthrightly framed by his work, as are John Goodyear and Wendy Ross who, by the way, is busy poring over *Sculpture* magazine. The frame, a presentation device usually associated with painting (and photography), is a recurrent theme in this portfolio. The head of Philip Grausman, best known for sculpting monumental stylized heads, has been framed out in white. J. Seward Johnson's recent work has been concerned with sculptural iterations of images appropriated from iconic French Impressionist painting. Ricardo shows him framed with, and framing, his 3-D outdoor installation of Manet's *Dejéuner sur l'herbe*. And with a trick of light and mirrors, Ricardo presents Harriet

Marilyn W. Simon

Caroline Gibson

Joseph Acquah

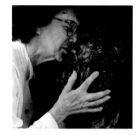

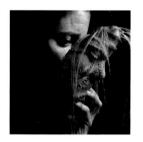

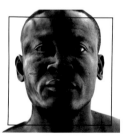

6

Casdin-Silver, the world's foremost holographic artist, as if she were appearing in a hologram. This *trompe-l'oeil* illusion is most fitting for the portrait of an artist whose chosen medium occupies a territory somewhere between photography and sculpture, between two and three dimensions.

Ricardo's diversity of photographic approach approximates the diversity of his sitters and their work, and thus the pluralism of the contemporary sculpture community as a whole. The portfolio, along with this book, which is a microcosm of the larger project, provides a reasonable though not encyclopedic cross-section of contemporary sculptural materials and styles. The community is also faithfully represented by its members included here. Some, like Segal, Marisol, and Magdalena Abakanowicz, are internationally recognized artists, figures who have already entered the art history texts. Others enjoy prominent careers with major museum exhibitions, private and public commissions, and prestigious gallery representation. Still others are "emerging artists," a catch-all phrase used to indicate young artists right out of school, artists just embarked on serious careers, or artists that are best known within their own geographic regions. These artists are the bulk and bulwark of both the world of contemporary sculpture, and the photographic project described here in this book.

Facing Sculpture is a loving and humanistic apologia for art, creativity, and risk. In a rich interpretive dialectic, Ricardo's photographs address and enmesh two layers of human expressive endeavor: sculpture and photography. They also insistently reveal the human presence behind the work of art. This task, so thoroughly and beautifully accomplished here, is important to perform for many reasons. By presenting artists as people, of many ages, colors, and inclinations, who are serious, thoughtful, and worthy of our extended attention and consideration, Ricardo helps to smash the still-prevailing stereotype of artists as

Philip Grausman

George Segal

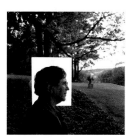

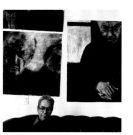

inscrutable one-eared garret-dwelling malcontents. In truth, as this body of work acknowledges, most sculptors in America in the early twenty-first century are responsible highly-educated middle-income citizens, imaginative individuals who happen to communicate more clearly and effectively with objects than with words.

Defeating the stereotype in turn helps to erase the state of alienation that often exists between artists and non-artists, an unnecessary and artificial divide actively perpetuated by commercial art galleries and the media, which both have something to sell. Mystique is marketable, and artists and their work are commodified and dehumanized as they become twisted into either products or freaks. Most artists are not interested in this kind of salesmanship. Most do not aspire to celebrity, and many sacrifice the possible remuneration of the American Dream to pursue creative lives. Commerce is how we live, but art is why we live. Ricardo Barros knows this, and so do the sculptors.

Nick Capasso

Curator
DeCordova Museum and Sculpture Park
Lincoln, Massachusetts

9

Portraits *Sculpture* *Ideas*

PHILIP GRAUSMAN

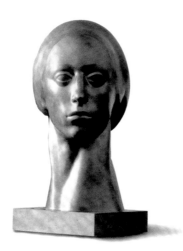

Leucantha, 1988-1993. Aluminum, 9 x 5 x 6.5'

GRAUSMAN is best known for his elegant renderings of the human head. He models his busts in clay and prefers to cast them in white metals, such as pewter, aluminum and zinc. His large metal heads conjure a presence of heroic proportions. As portraits, each subject's identifying features are reduced to their simplest line and form, and the finished works assume a stately elegance.

Photographed outside his Connecticut home

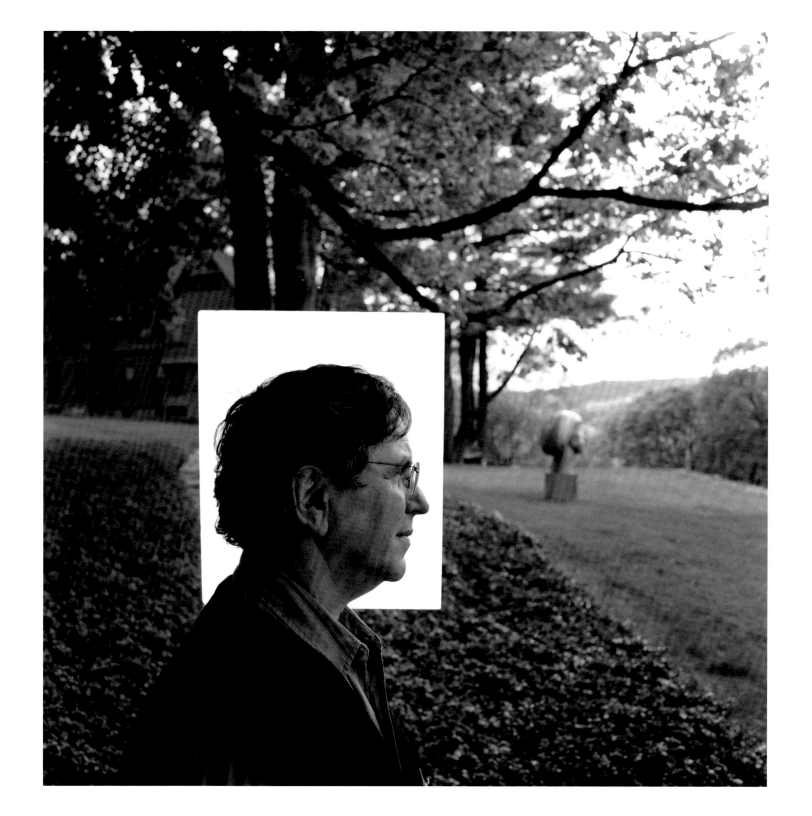

PETER LUNDBERG

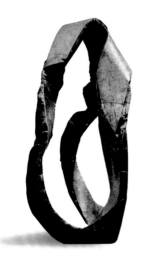

Now Euclid, 1998. Concrete and steel, 22 x 10 x 10'

LUNDBERG sculpts massive, up-ended loops of concrete and steel. His structures are cast through multiple pours of concrete into a carefully planned excavation. He lines one side of the excavated hole with metal sheets, and these remain visible in the finished work. A gantry system is necessary to rotate the partially completed structure, and a crane is required for installation. Lundberg draws upon a mathematical background and designs his sculpture in accordance with the Mobius Strip concept. The Mobius Strip is a geometric anomaly where, by twisting into itself, a structure can seemingly shed one of its dimensions.

Photographed inside the George Washington Bridge ramp system with Now Euclid →

14

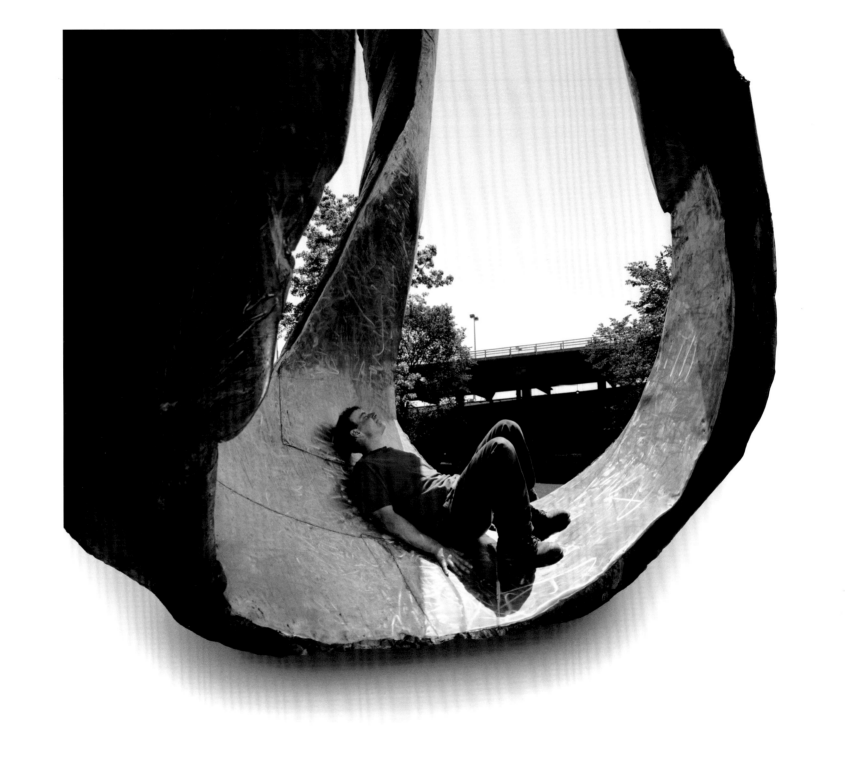

PHIL SUMPTER

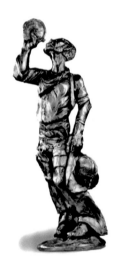

Dry Canteen, 2000. Cast resin, 18 x 4 x 4"

SUMPTER casts figurative works that embody both legend and fact. A self-described cowboy artist, he specializes in depicting African-American cowhands and Buffalo Soldiers. Despite these Americans representing 15 to 20 percent of the cowboys and cavalrymen on the Western frontier after the Civil War, they are conspicuously missing from most depictions of our national history at that time.

Photographed outside his Philadelphia studio →

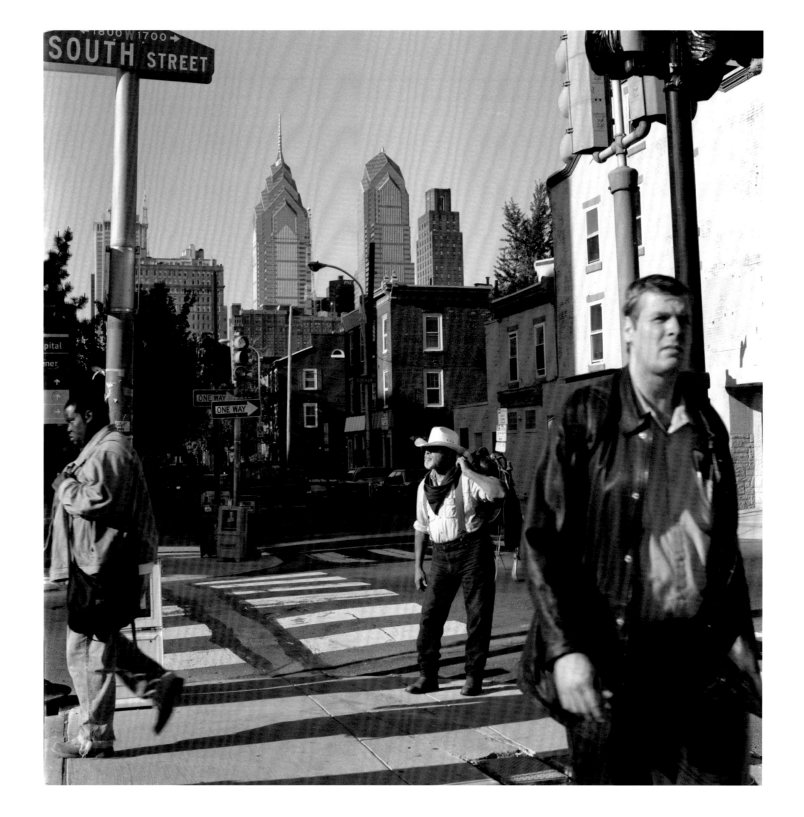

MAGDALENA ABAKANOWICZ

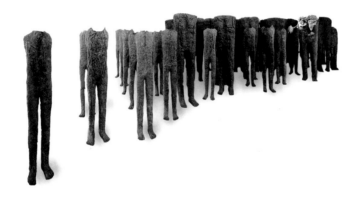

Crowd III and Infantes, 1989. Burlap and resin; fifty figures, each 67 x 22 x 8"

ABAKANOWICZ' sculpture takes can take many forms, among them wood, cloth, metal, and stone. Her semi-figurative people are of a scale slightly larger than life and shaped from resin-impregnated burlap. These figures are headless, often presented in a crowd, and through them Abakanowicz addresses somber human traits. These include our capacity for the unspeakable violation of others, our ability to cloak cruel acts with anonymity, and our paradoxical instinct to survive as individuals.

Photographed at Grounds for Sculpture →

RICO EASTMAN

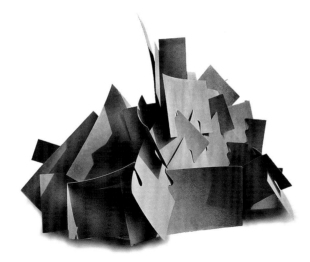

Standing Wave, 2000. Corten steel, 144 x 280 x 144"

The steel facets in E A S T M A N ' S sculptures nestle in a complex, slotted arrangement that is secured by spring tension in their curvature. Eastman's work suggests the interconnectedness, rather than linear nature, of our personal histories. C may follow B, which follows A, but the effects of the latter events are interlocked with our changing perception of those that preceded them. Like a house of cards, we can choose to add new elements to the matrix, but we can't choose which pieces to eliminate. Truthful understanding is a transitory, multi-dimensional process, which may collapse if one tries too hard to impose a narrative order. Puzzle-like, his sculptures are an apt metaphor for life rhythms we intuitively understand but may never sort out.

Photographed in his New Mexico studio with Standing Wave →

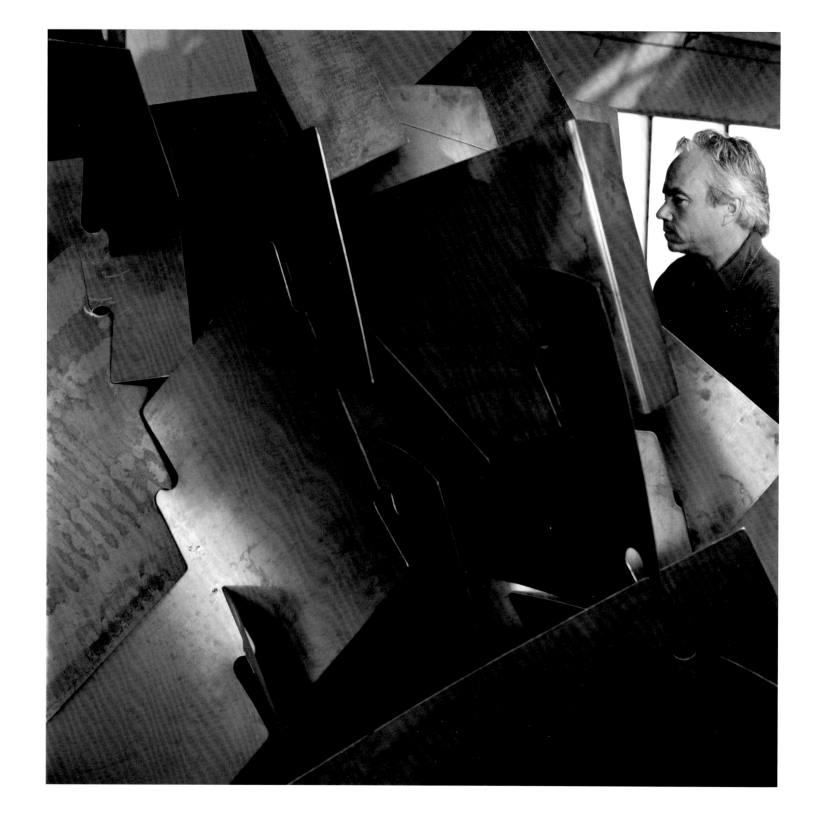

CAROLINE GIBSON

Ordinary Secrets 2002. (Installation detail.) Nylon fly screen, paper, buttons,
cast silicon rubber, copper chore boys, approx. 72 x 38 x 15"

G I B S O N uses hardware store supplies to address the issue of personal appearance. Appearances have a profound impact on our lives. The degree to which we are socially accepted is determined in large part by the way in which we are perceived. Gibson observes that life is an affair of putting on and taking off clothes, ranging from secret undergarments to visible outer-wear. These additional skins are critical to our physical and emotional survival. Public presentation of identity can provoke a strong, irrational response. Using tarpaper, window screen, aluminum flashing and rawhide, Gibson brings to the forefront a need for the re-evaluation of social expectation, especially those associated with gender.

Photographed in my New Jersey living room with Rawhide Mask →

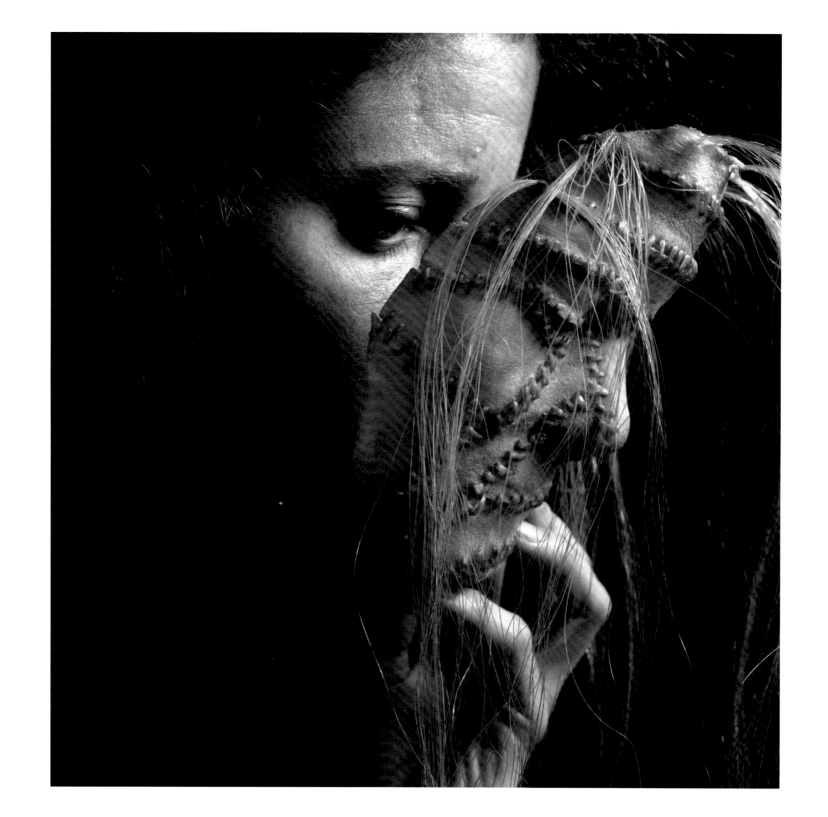

JULES SCHAEFFER

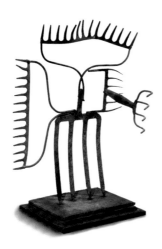

Personnage, 2001. Rakes and pitchfork, 24 x 18 x 14"

S C H A E F F E R is a surrealist sculptor. His materials are often found objects, devoid of value in the eyes of their previous owner, which he manages to infuse with unexpected interest in an entirely new context. Schaeffer juxtaposes disparate elements in concise, sculptural assemblages. Because of the way in which he selects and combines them, the individual elements reveal an underlying affinity that survives the oddity of their unorthodox pairing. His work conveys a sense of heightened expectancy.

Photographed at home in New Jersey →

JOHN VAN ALSTINE

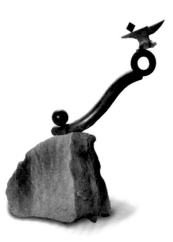

Juggler 1, 1993. Granite, bronze, 98 x 80 x 32"

VAN ALSTINE'S sculptures are poised, determined accomplishments. Like a powerful dancer mid-leap, his work buoyantly defies natural laws. Van Alstine choreographs massive rocks and cast-off industrial parts into a weightless suspension of forms. Presented freeze-frame and at the apex of their implied motion, these forms exude confidence and balance; each composition is as fluid as a dancer's body. Our thoughts of rational implausibility are seduced by grace in the ensemble.

Photographed at his Adirondak studio with Doryphorus, in progress →

26

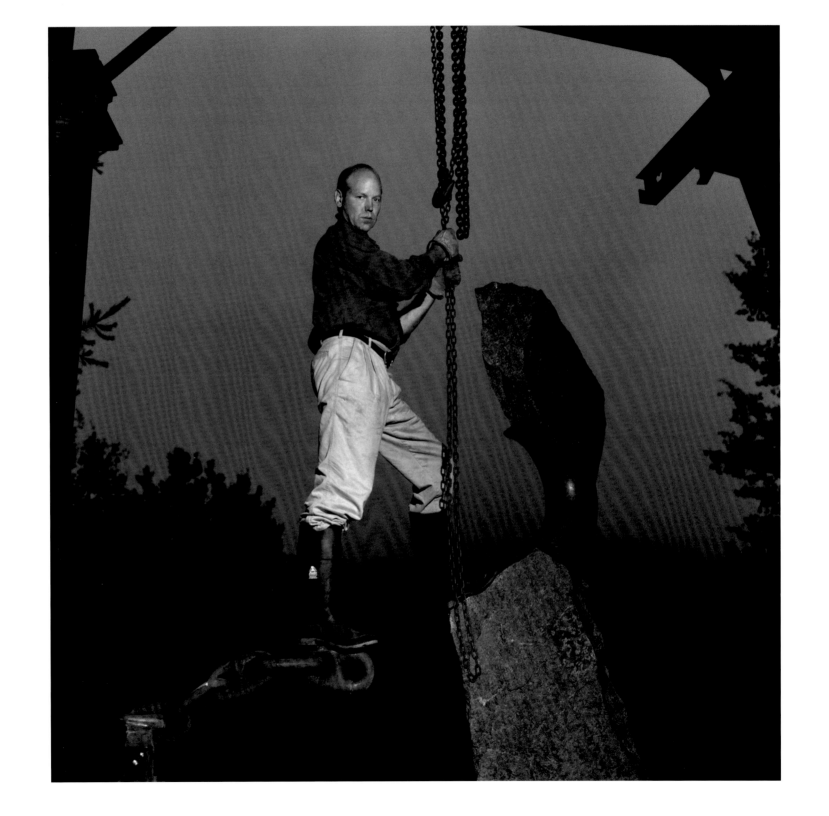

MICHAEL STEINER

Three Graces, 1994. Steel, 78 x 72 x 72"

S T E I N E R is a highly accomplished sculptor producing bold, strident works. He welds together both new and recycled metal plates, reshaping some with a blowtorch as he proceeds, to arrive at a pure and abstract whole. His sculptures have no literal interpretation; they have no front, side or back. His geometric forms echo one another in a delicate balance. At times, like a coin spinning on a flat mirror surface, his work suggests a visual rhythm that fuses perception of time and space.

Photographed in his Connecticut studio

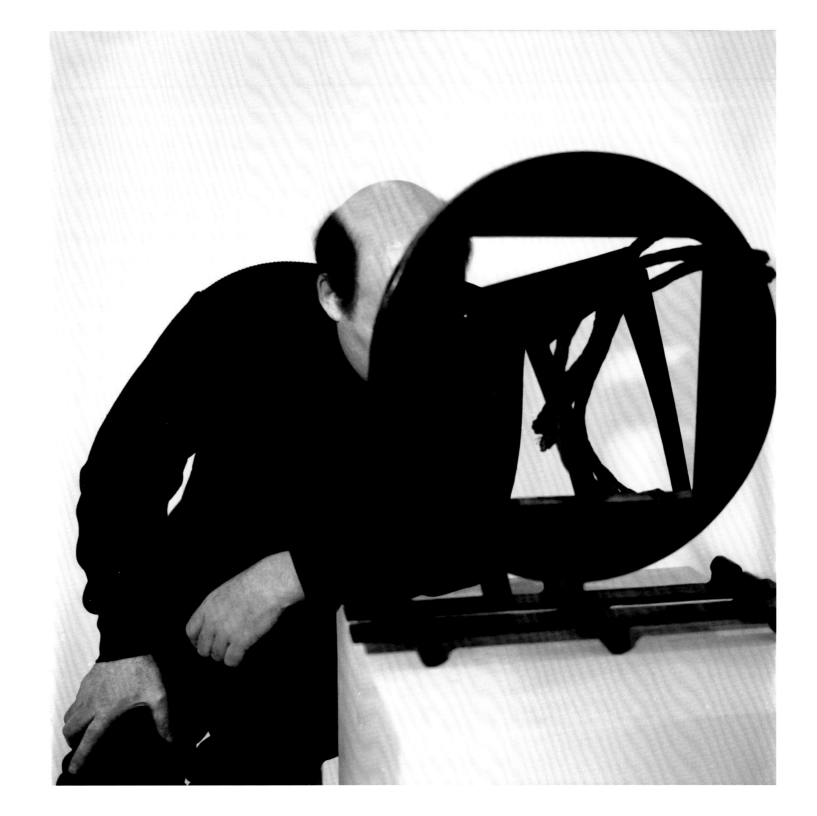

MARILYN W. SIMON

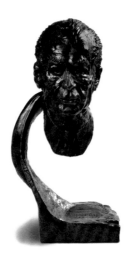

Yhitzak Rabin, Peace Maker, 1996. Bronze, 25 x 13 x 9"

SIMON, a prolific artist, invests her heart into each and every one of her works. Modeling her portraits in clay, she carries on an intuitive dialogue with her subjects, often finding that their expressions may change with the changing light. She sculpts until the work informs her it is complete. Her commissioned sculpture of Yhitzak Rabin, the slain Prime Minister of Israel, reflects her respect for his courage, understanding, and vision of peace.

Photographed in my studio→

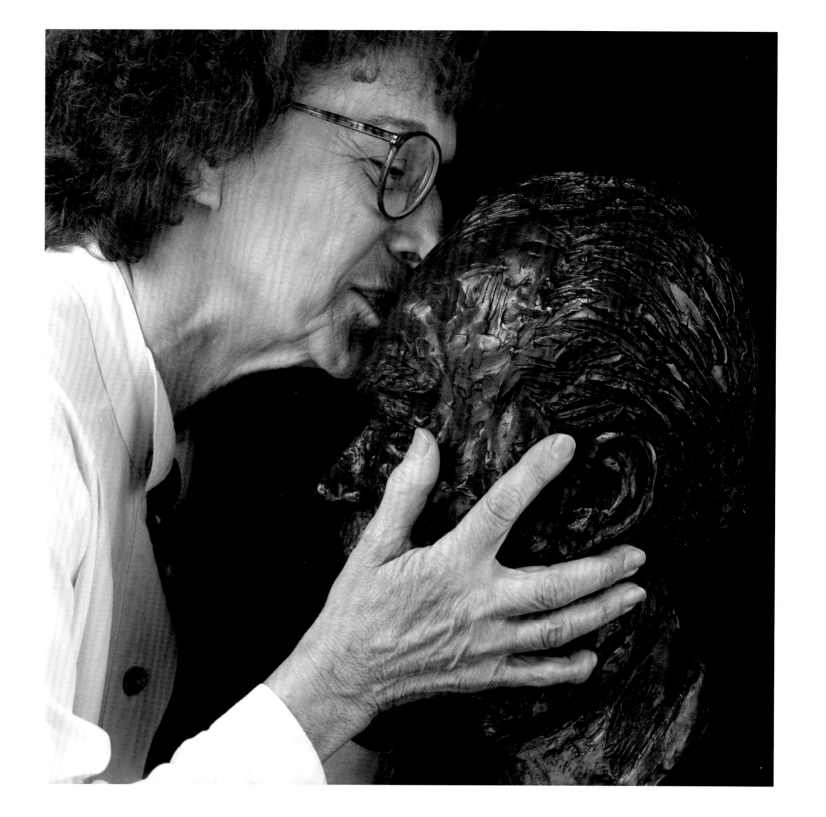

CHAKAIA BOOKER

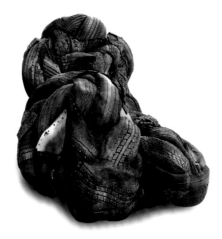

Untitled (Male Torso That Left His Path,) 1992-1995. Rubber tires, wood, 60 x 66 42"

BOOKER recycles spent tires into art. Their black rubber surfaces are folded, sliced, and woven into large complex forms that speak of layers, depth, and the product of human industry. Booker observes that the tire tread design is abstractly African – it resembles motifs used in African fabrics, ritual scarrings and in other artworks. In their composite shape, her folded rubber sculpture sometimes takes on surprisingly humanistic forms, and through these she addresses ethnic and environmental concerns.

Photographed in her New York City studio →

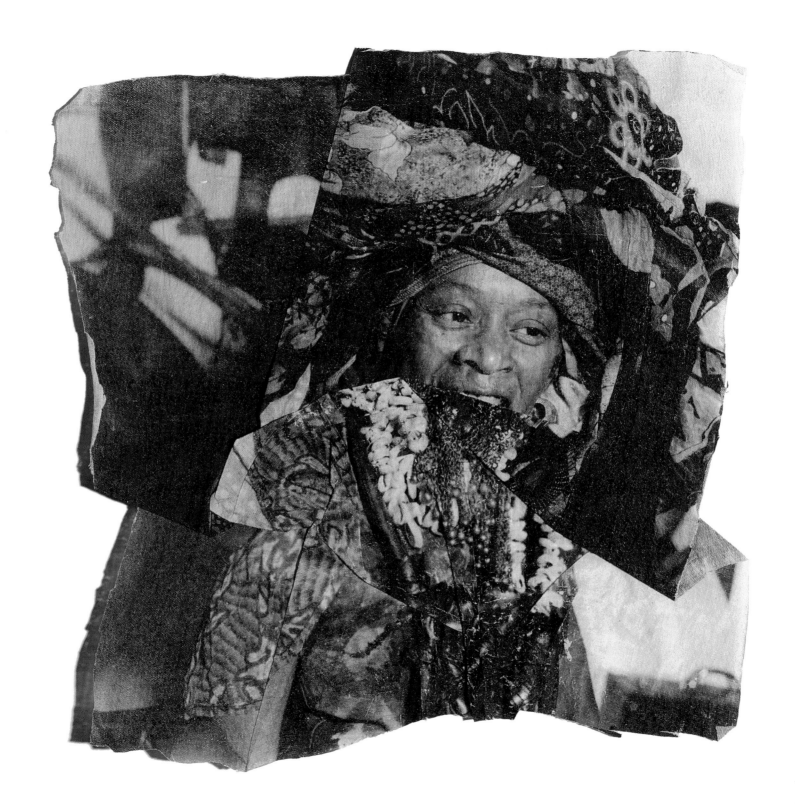

CHARLES GINNEVER

Troika, 1976. Corten steel, 13 x 20 x 6'

GINNEVER makes seemingly rectilinear sculpture out of flat plates of steel. Closer inspection reveals unexpected metal seams which, because of an Escher-like geometry, undo one's perception of space. It can be difficult to predict what the side view of a Ginnever piece will reveal when the sculpture is approached from the front.

Photographed on his Vermont farm →

HELENA LUKÁŠOVÁ

Beetle People, 1999. Bronze and rabbit fur, 16 x 5 x 6"

LUKÁŠOVÁ is a highly resourceful sculptor. When access to costly materials is difficult, she resupplies by visiting the Five & Dime to produce new works without breaking her stride. Lukášová sculpts life-size cloaks, ready for casting, by spreading melted wax onto bubble wrap packing material. The smaller cloaks of her tabletop figures were once rabbit fur purses. Her works suggest an archeological record, credible both as artifacts unearthed and artwork produced. The sculpture suggests fragments of an earlier society, one with daily rituals we may accept as intuitively familiar but do not understand. They succeed in triggering a cognitive response without relinquishing the secret of their meaning.

Photographed in my studio with Wings and Headdress, both in the wax stage of the casting process→

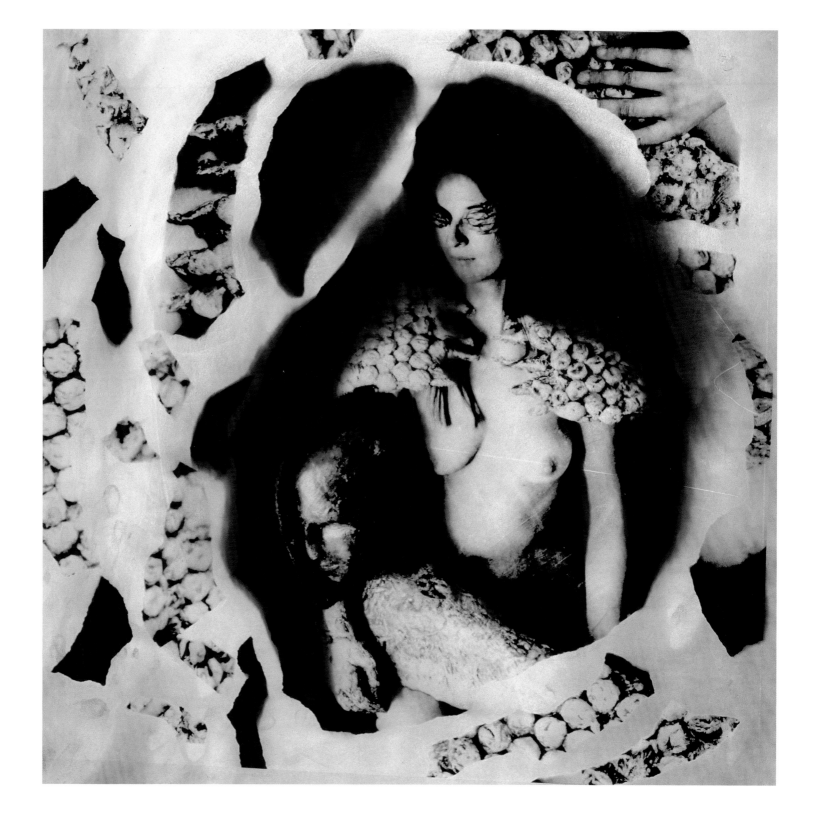

BILL BOTZOW

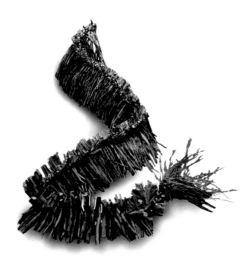

Bemoth, 1999. Maple, wire and rope, 7 x 110 x 7'

BOTZOW makes site-specific installations using indigenous materials that address issues relevant to the global community. Bemoth, a sinuous arrangement of tree limbs, calls attention to the lower echelons of the food chain. With decay and its subsequent consumption, much of the wood in this sculpture will eventually be, quite literally, moths.

Photographed in forest behind his Vermont home →

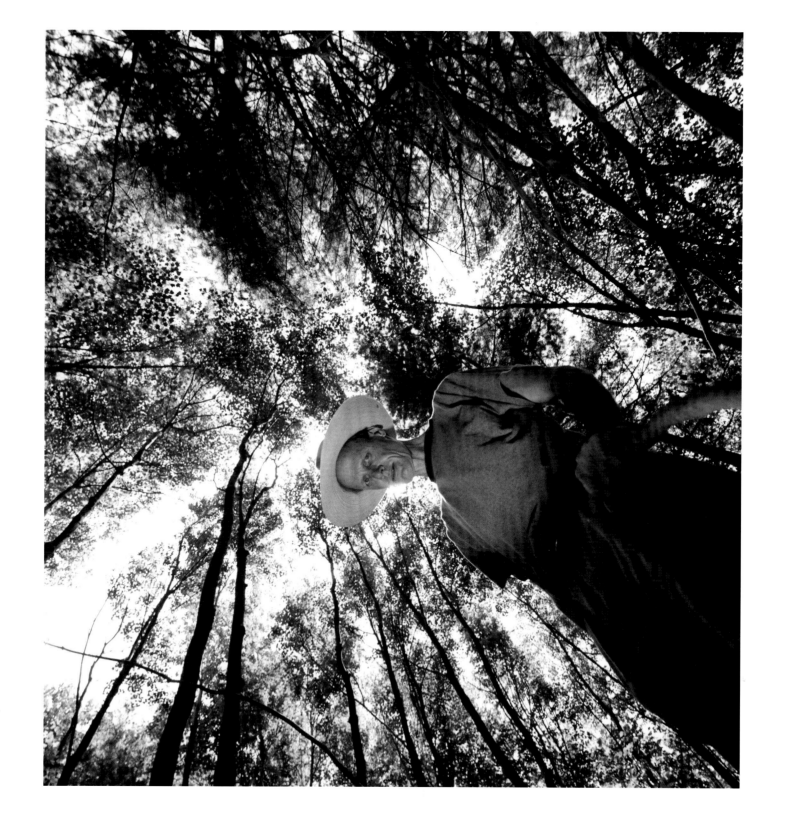

CHARLES WELLS

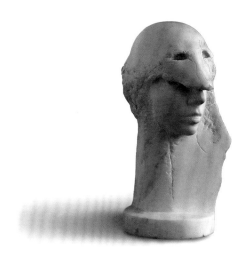

Skull Helmet, 1992. Danby Vermont marble, 18 x 11 x 11"

W E L L S carves both wood and stone. He speaks only practically about his work – he created angels by adding wings to fig-ures so as to have a larger surface to decorate – and he declines to comment on the subtle mysteries that his pieces invoke. He is a delicate craftsman, carving by the flickering flame of intuition to produce sculpture that retains its enigma in the full light of day. If we want to know more, we have to squint our own eyes and hope for a glimpse of what he saw between the shadows.

Photographed in entrance of his Pennsylvania farm,
childhood home and current residence, pulling Turtle Lady →

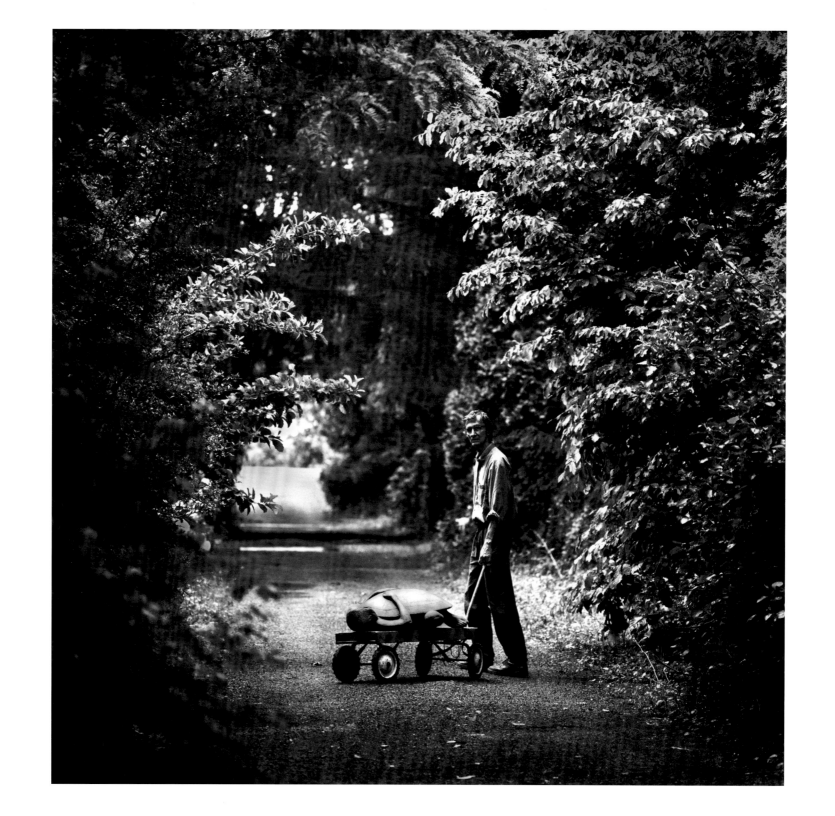

AUTIN WRIGHT

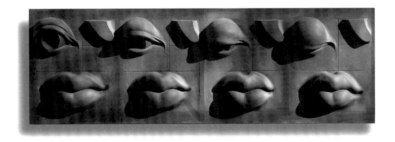

The Sleep, 1997. Cast aluminum, 31 x 98 x 6"

W R I G H T is capable of producing realistic, figurative work but prefers more abstract forms of expression. His sculpture, Sleep, is a blend of the two extremes. This sculpture's four, contiguous panels, similar to those of a storyboard, depict a person's transition from a waking state to that of repose. One eye plays the lead role in this drama and the lips deliver a subtle, supporting performance. They pucker ever so slightly. In rendering his figurative elements, Wright suggests just the right amount of realism; the facial features are instantly recognizable. And, with a nod to his non-representational bent, their forms are greatly simplified, making the face highly abstract. One hardly notices that this face is asymmetrical and incomplete. Wright masterfully directs our attention to the quiet transition.

Photographed at Grounds for Sculpture with The Sleep →

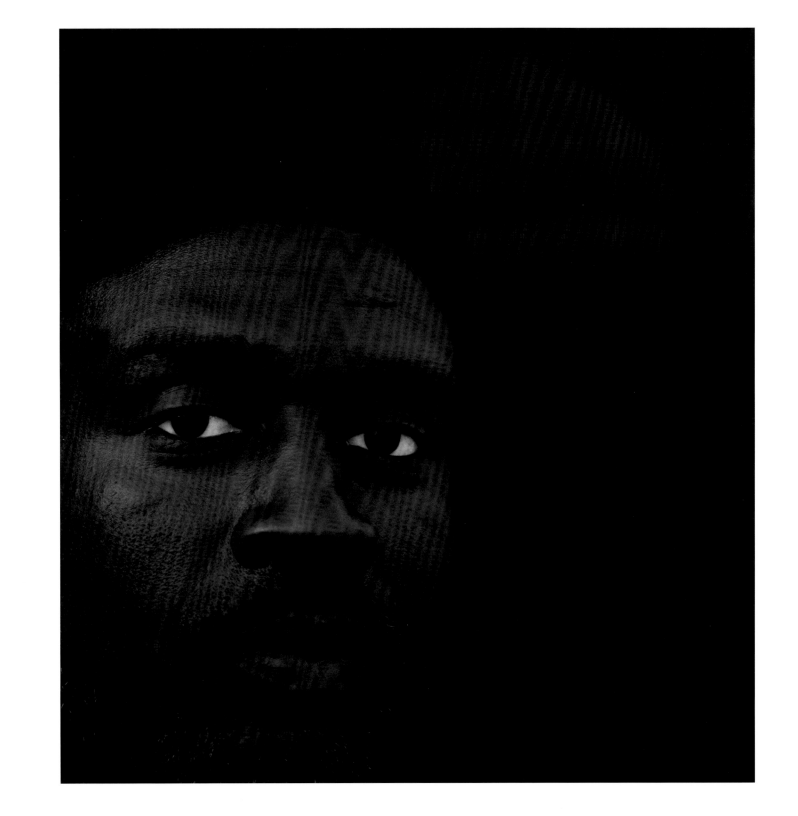

ROBERT RESSLER

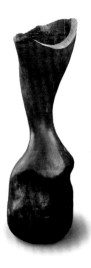

Aluna, 1997. Cast bronze, 125 x 48 x 48"

RESSLER whittles trees intuitively, substantially altering their form without significantly diminishing their size. Initially using a chainsaw, he carves preliminary shapes out of felled limbs and trunks, progressing to finer hand tools as his vision emerges. His finished works retain the sense of organic movement and growth. Both figurative and, more recently, abstract, his works employ simplified forms to present a sympathetic, robust interpretation of life in the natural world.

Photographed in his New York studio→

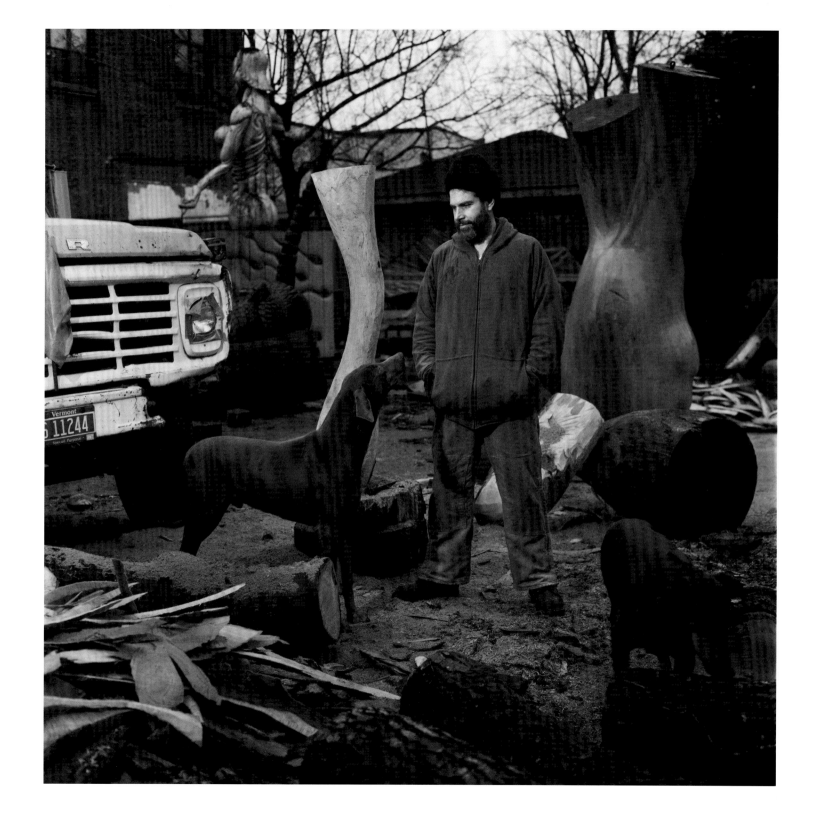

George Segal

Legend of Lot, 1958. (Detail.) Wire armature, burlap, plaster, 65 x 24 x 25"

S E G A L is best known for coarse, plaster figures depicting quiet moments of twentieth century urban life. He cast his sculptures from life using white plaster and a technique similar to that of a physician setting a bone. Early on, he was intrigued by the coarseness of the cast's exterior surface. This surface often masked identifying detail in but not the characteristic gesture of live models holding still until the plaster hardened. Late in his career, Segal developed an interest in charcoal drawings. Here, with rough strokes that could only blacken paper, he captured surface details that complement his white plaster castings.

Photographed in his New Jersey studio →

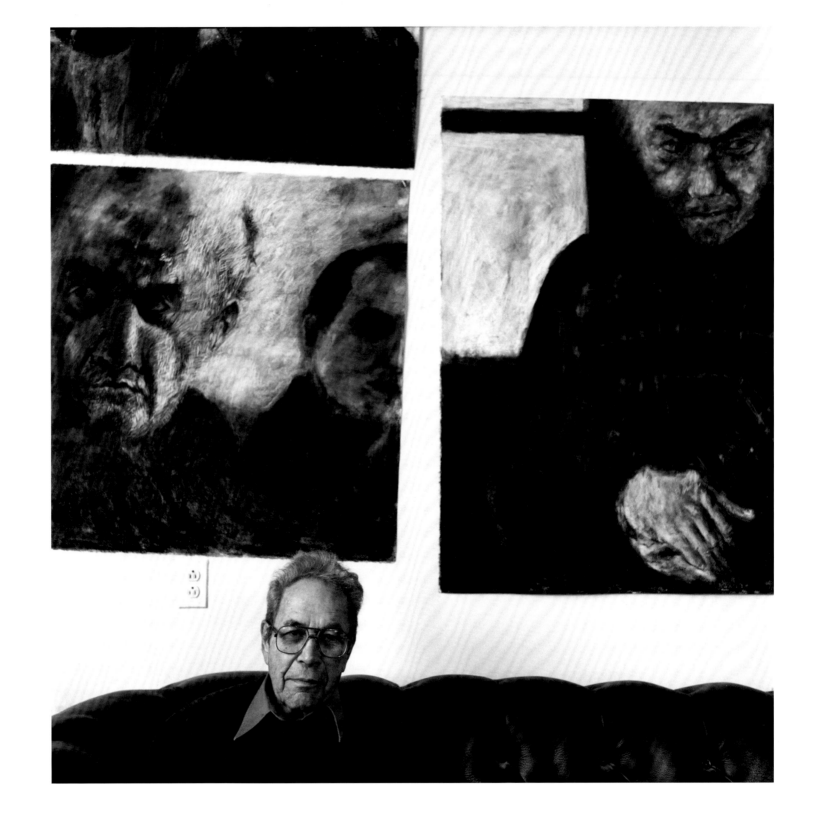

SYDNEY BLUM

9x WRVH Flock Left, 1999. Cement and peat moss; nine elements, each 28 x 14 x 14"

One aspect of B L U M ' S work addresses grief. Her cement dwellings are suggestive of primitive long-houses where the remains of ancestors were placed with honor. But in Blum's case, the dwellings' distorted shapes and partial decay concede the toll that mortality takes on the living, and the grouping of her houses remind us that we all have a place in our own village.

Photographed at her New York studio →

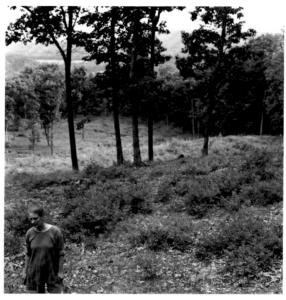

J. Seward Johnson, Jr.

A Turn of the Century, 1995. Cast bronze, 71 x 44 x 51"

JOHNSON, Founder of Grounds For Sculpture, recreates Impressionist and Post Impressionist paintings in bronze, meticulously retaining the painter's perspective. He exploits the spatial dimension of sculpture by inviting the public to walk inside his installations. The paintings Johnson re-creates were themselves each an interpretive composite of several vantages. The scenes did not exist as they are depicted. Johnson's sculpture thus presents a portal through which we can interactively access the painter's mind's eye.

Photographed at Grounds For Sculpture with Déjeuner Déjà Vu →

JOAN DANZIGER

Procession, 1980. Resin-reinforced fabric over wood and wire armature, celluclay paint, 41 x 98 x 45"

DANZIGER stretches glue soaked muslin over a wire armature to bring her figurative sculpture to life. Her work represents a personal mythology, a magical intermingling of species, fantasy and reality. She draws her inspiration from dream imagery rich with benign, if unexpected, metamorphoses.

Photographed in her Washington, D.C. backyard →

JOSEPH ACQUAH

To God be the Glory, 2000. Bronze, 23 x 7 x 5"

ACQUAH is a deeply spiritual man who humbly seeks to honor the Lord's creations. Often, rather than trying to improve upon His work, Acquah will render from life with near-exact likeness. It is this artist's way of showing respect. A native of Ghana, whose face is decorated with ritual scars on both cheeks, Acquah strove for accuracy in his self-portrait. With extraordinary attention to detail, he used calipers, mirrors and photographs to reproduce in bronze a life-size bust of himself. Others of his works show a similar respect for the Creator.

Photographed in my studio with his bronze self-portrait

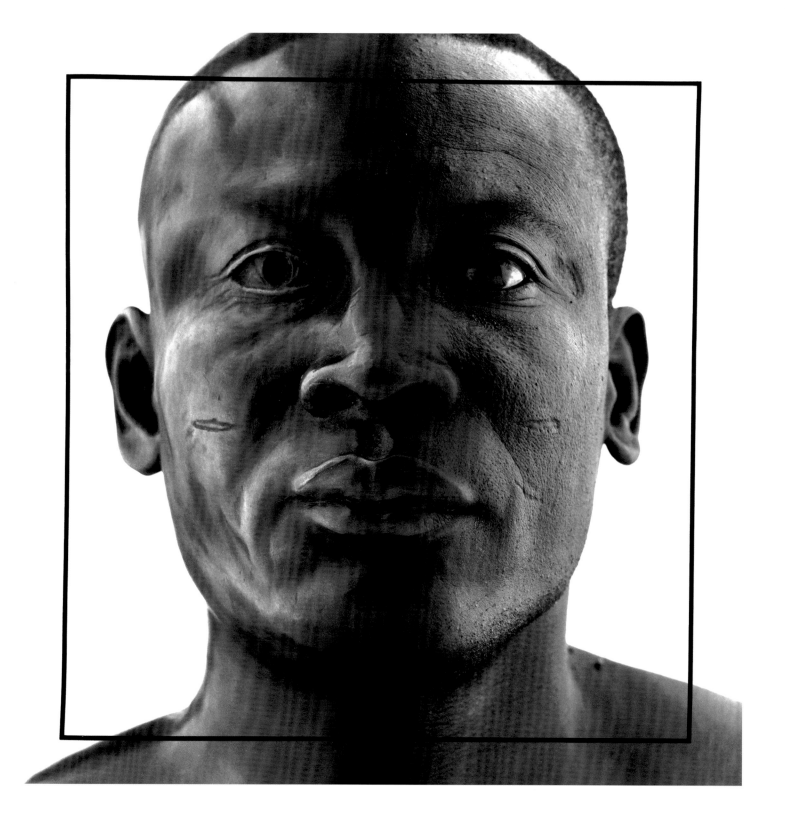

MICHELE OKA DONER

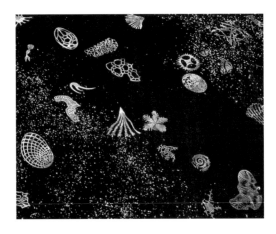

A Walk on the Beach, 1995. 2,000 bronze elements embedded in a matrix of terrazzo and mother-of-pearl; half-mile long concourse floor.

DONER casts three-dimensional forms into sculpture which is constrained by two-dimensional surfaces. For A Walk on the Beach, a half-mile long pedestrian walkway in the Miami International Airport, she embedded 2,000 bronze elements evoking marine life into the terrazzo floor. Her bronze castings were only partially submerged into the floor. When the terrazzo hardened, Doner ground the protruding metal flush to the smoothened surface. Still visible in between the bronze elements are small, luminescent bits of mother-of-pearl that Doner had sprinkled into the still-wet terrazzo mix. They suggest swirling foam trapped deep below the pedestrian's feet in an imagined marine environment.

Photographed with ceramic elements in her New York studio →

NEIL ESTERN

Franklin Delano Roosevelt Memorial, 1997. (Detail) Bronze, 107" high

ESTERN is a figurative sculptor best known for his monumental portrait of Franklin Delano Roosevelt, in Washington, DC. Working in a traditional vein, Estern seeks to capture the aura projected by each of his subjects. This can be especially difficult when working on a public art commission. Committees often mandate interpretive decisions independently from the artist's intent. The FDR Memorial, for example, had foundered in committee deliberation for 9 years before it was funded in 1955, only to be stalled in committee yet again for the next 36 years. One issue Estern was forced to address was the President's physical disability: was it appropriate to hail FDR as a role model for overcoming the challenges presented by polio, or should this personal infirmity be downplayed, as the President himself preferred? With a gracefully draped cape that still revealed wheels on the far side of FDR's chair, Estern navigated the process and sculpted a fitting tribute to the 32nd President.

Photographed on his Brooklyn, New York, doorstep →

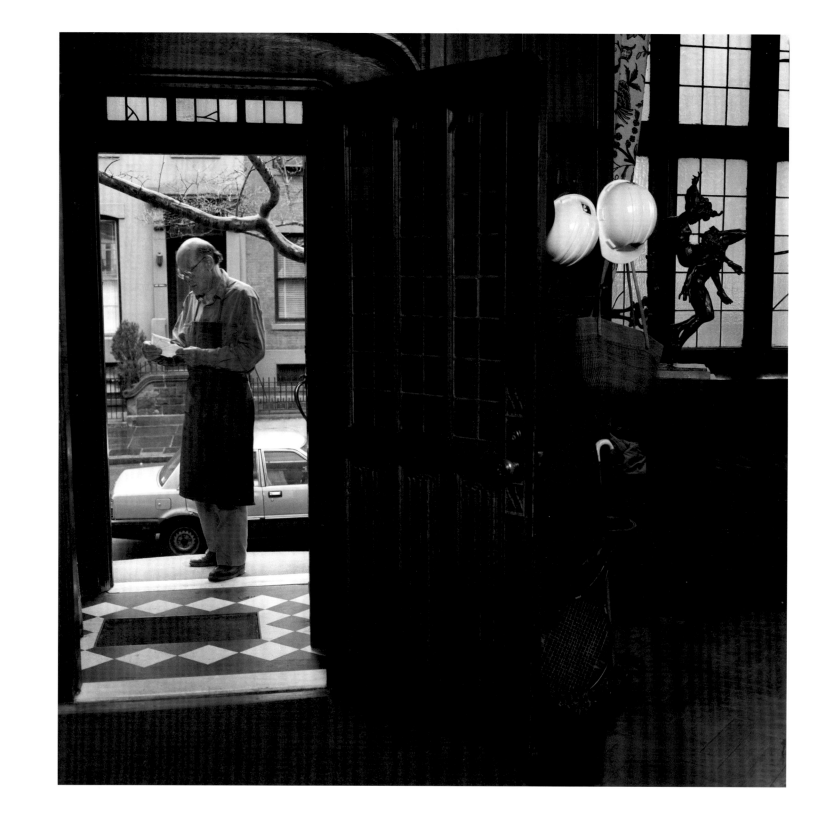

TOVA BECK-FRIEDMAN

Excerpts of a Lost Forest: Homage to Ashera, 1992. (Detail) Ferro-cement, vinyl concrete, black pigment; five elements, each 96" high

BECK-FRIEDMAN sculpts coarsely fashioned, totemic landmarks. Whether she works in stone, cement or pulped paper, her works suggest weight and mass. Their textured surfaces show the aging process measured on a geologic scale, and many of the forms are split into elongated openings that hint of a feminine deity. Beck-Friedman arranges these pieces into enigmatic groupings. Hand worked, their positioning implies that a secret order underlies their placement. They can be read as evidence that an earlier people, conscious of their own mortality, sought to pass sacred rituals down through the ages. But these totems are mute; they withhold information. While the voices of their mythical makers may be lost to the centuries, we clearly understand that the priests, or perhaps priestesses, who came before us were compelled to speak.

Photographed in her New Jersey loft →

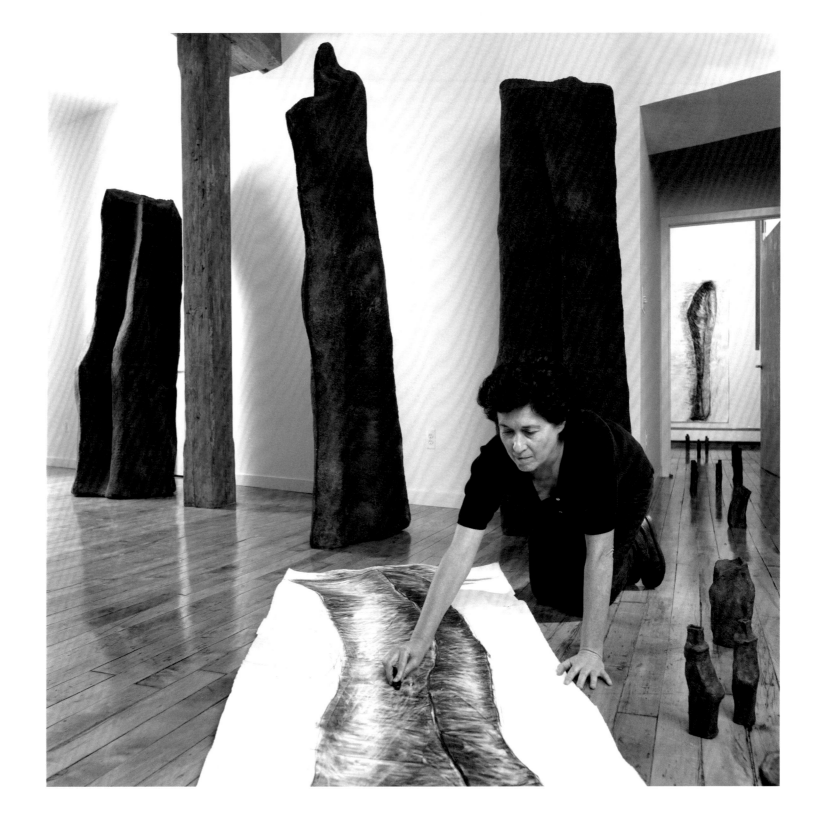

JOHN HOCK

Prometheus, 1995. Steel, 24 x 24 x 14'

H O C K is a constructivist sculptor. He carves up pre-existing objects, reassembles and then welds them into constructions with a new identity. His sculptures are exuberant; they retain the playful energy of a small boy lost in his Tinker Toy fantasy. But Hock's world is for real, and he works large. His toys include cranes, front-end loaders and backhoes. His building blocks are concrete mixers and water tower tanks that he keeps in a recycled Minnesota cornfield, now a playpen for artists. Hock is co-founder of Franconia Sculpture Park, a unique, outdoor workshop where emerging artists are invited to create and display their work on-site. In his capacity as host, Hock will personally mow a path through the tall grass to the works on display.

Photographed at Franconia Sculpture Park in Shafer, Minnesota →

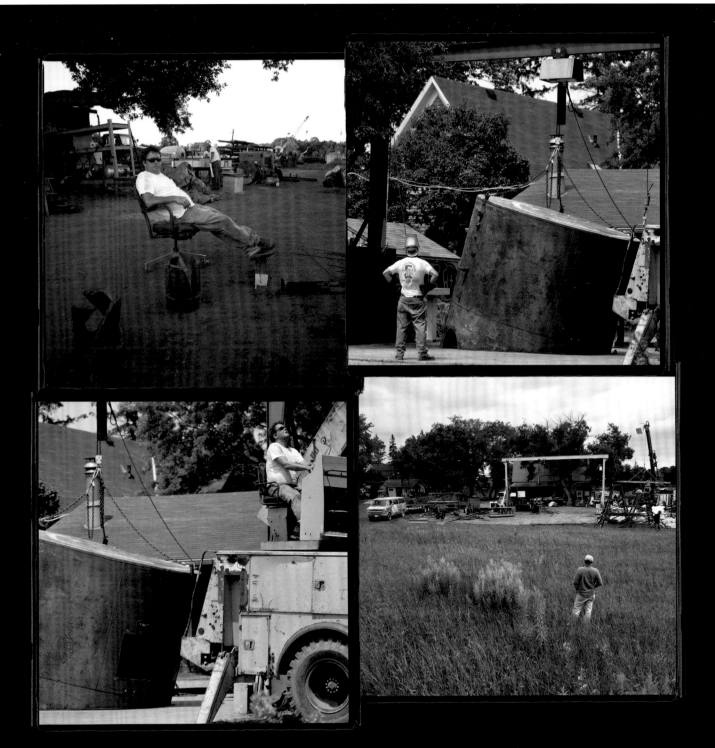

WENDY ROSS

Radiolaria, 2000. Stainless steel, 9 x 21 x 9'

R O S S works with an extremely strong material – steel – to produce visually delicate structures. If there were such a title, Ross might be called an Aesthetic Physiologist. She studies biological organisms, creatures ranging in size from microscopic marine protozoa to plainly visible sea anemones. She reinterprets their structure and re-expresses their forms on a different scale to meet her own, artistic needs. Like a spider weaving her web, she spins – or, in this case, welds – a linear material to form patterns that arch across space. These patterns replicate themselves to generate complex symmetries around internal axes. Her sculptures have a physical integrity similar to that of their organic cousins: the forms indent when pressure is applied and spring back when that pressure is removed. Ross sustains life's energy in her imagined evolution.

Photographed in the driveway to her Maryland residence →

William King

Magic, 1972. Aluminum, 9 x 33 x 4"

K I N G works with flat, metal sheets to simplify form in figurative subjects. He reduces three-dimensional objects into a hand-ful of shaped, intersecting planes. His sculptures assert their claim to volume without actually consuming much space. Seen on edge, portions of his work disappear into a one-dimensional line. The figures are often not fully revealed from a single vantage point; viewers must circle the work and connect the planar elements within their minds' eyes. Each shape's delicate edge recap-tures textural information lost in the smooth metal surfaces.

Photographed in his Long Island backyard →

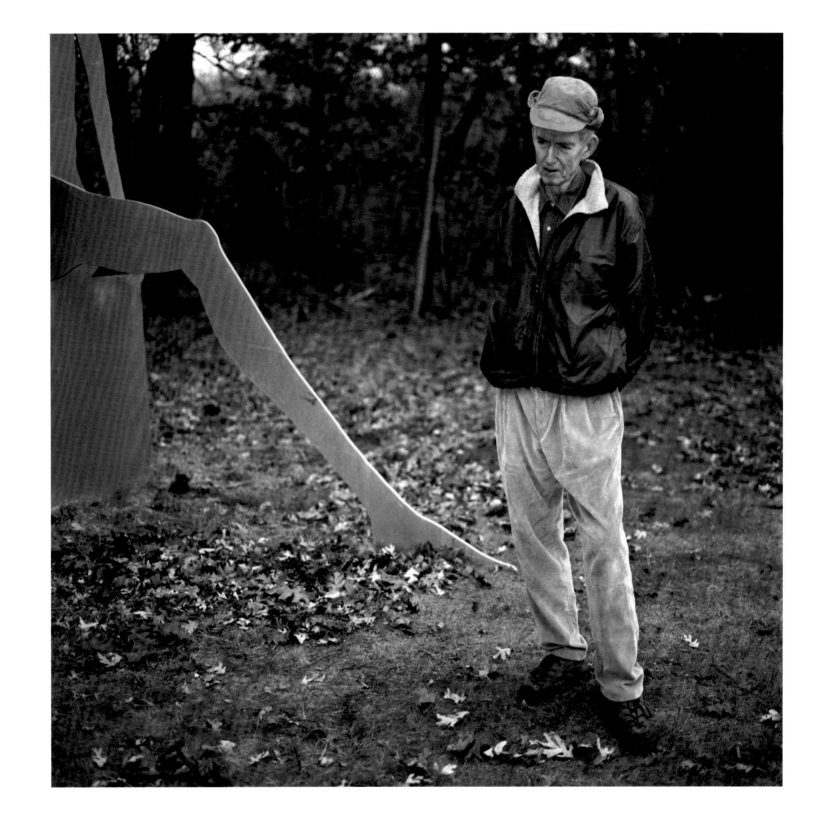

JOHN RUPPERT

Pumpkins, 1999. (Detail) Cast aluminum; five elements, each 29 x 43 x 42"

RUPPERT'S work harnesses the force of gravity, pulling the substance of which his sculpture is made earthwards to bend and reshape forms. The forms inherent to his original materials may be altered, but not the material's character. Ruppert finds beauty in the natural distortions. This is most clearly visible in his sculptures made with chain-link fence. Absent the posts, the fence assumes a blanket-like quality. He rolls the woven metal into various shapes, sometimes pinching one end with wire twist-ties, then lifts and suspends his new creation. Gravity pulls against structural constraints to reveal entirely new forms. In making life casts of enormous pumpkins, Ruppert addresses the same phenomena. A corpulent flesh is draped upon the spherical structure, bulging in its pull against ribs to reveal the pumpkin's luxurious forms.

Photographed in his Maryland studio →

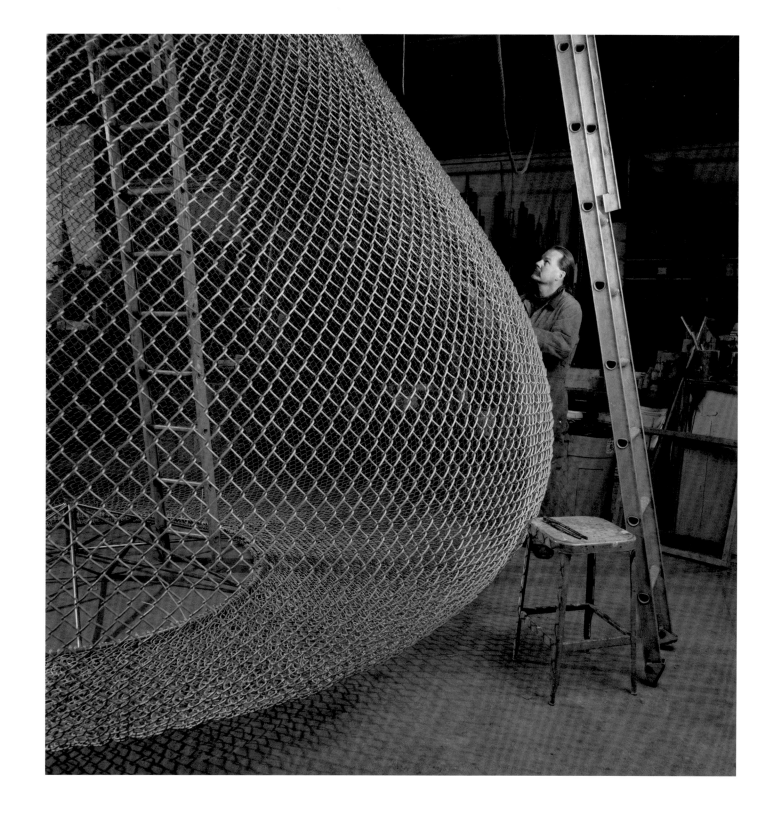

MEREDITH BERGMANN

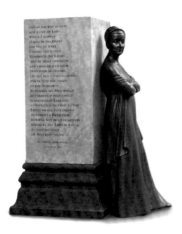

The Boston Women's Memorial, 2003. (Detail) Bronze figures, granite base, 6.5 x 30 x 30'

BERGMANN'S work is allegorical – it makes reference to story, whether it be a fable, a personal vignette or an historical event – and her sculpture brings to the telling a sense of disarming observation. For the Women's Memorial in Boston, for example, her commission was to honor three early feminists: Abigail Adams, Phillis Wheatley and Lucy Stone. Bergmann's hidden challenge lay in the siting of this work; the finished piece would be placed in a promenade already filled with statues of dead white men on granite pedestals. Her work had to assert an authority comparable to that of these patriarchs without acquiescing to values that generations of male leaders had imposed. Bergmann had her ladies step down from their pedestals. Each woman uses her pedestal as a platform upon which she can work, and as a slate upon which her message is written.

Photographed in her New York City bedroom

72

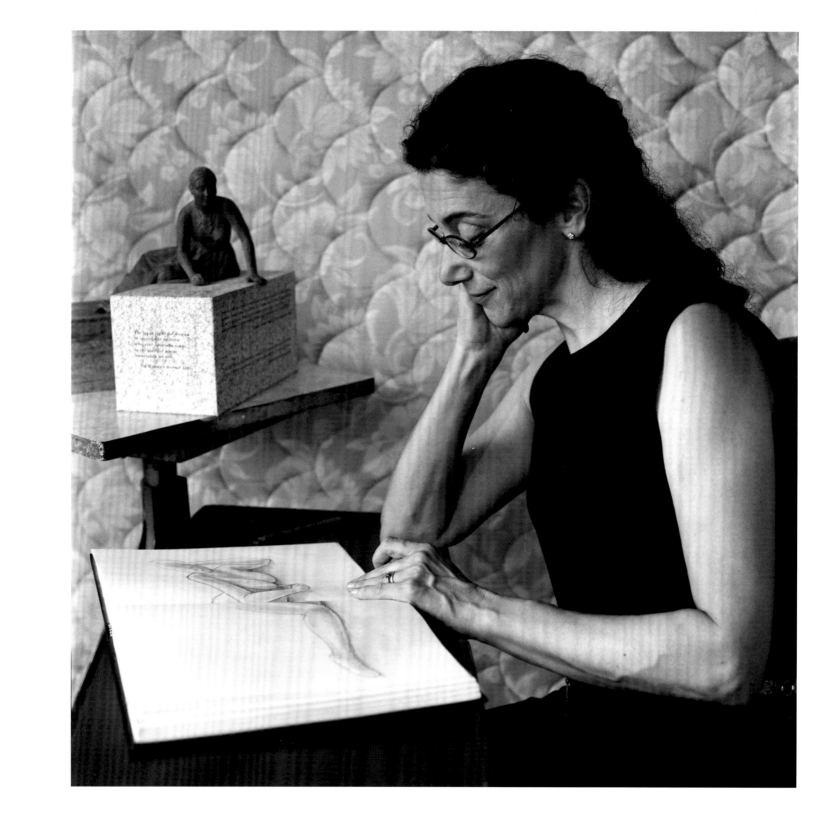

PAUL MATISSE

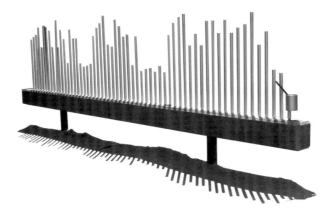

Musical Fence, 1980. Aluminum sounding bars and reinforced concrete, 6.5 x 1.5 x 20'

MATISSE has a keen interest in kinetic phenomena. His sculpture incorporates movement, whether that motion takes form as a mechanical displacement, an acoustic sound wave or the migration of color in a visual display. His interactive sculpture, Musical Fence, is a xylophone pitched to the aesthetics of its visual form and waiting to be struck with a nearby mallet. Second Wheel, a more mechanical piece, consists of a large flywheel equipped with a handle to start its rotation. As the wheel begins to spin, loosely bolted, hammer-like weights near the wheel's rim are set into motion. The small orbits of these two hammers quickly fall out of synch with the larger wheel's rotation, and then with each other's, forcing the flywheel to perform an idiosyncratic dance. The choreography is one of fits and starts, a jazz-fusion rhythm. Matisse does not aspire to control or to conduct the show, his intent is to set the performance in motion.

Photographed with Second Wheel in his Massachusetts studio →

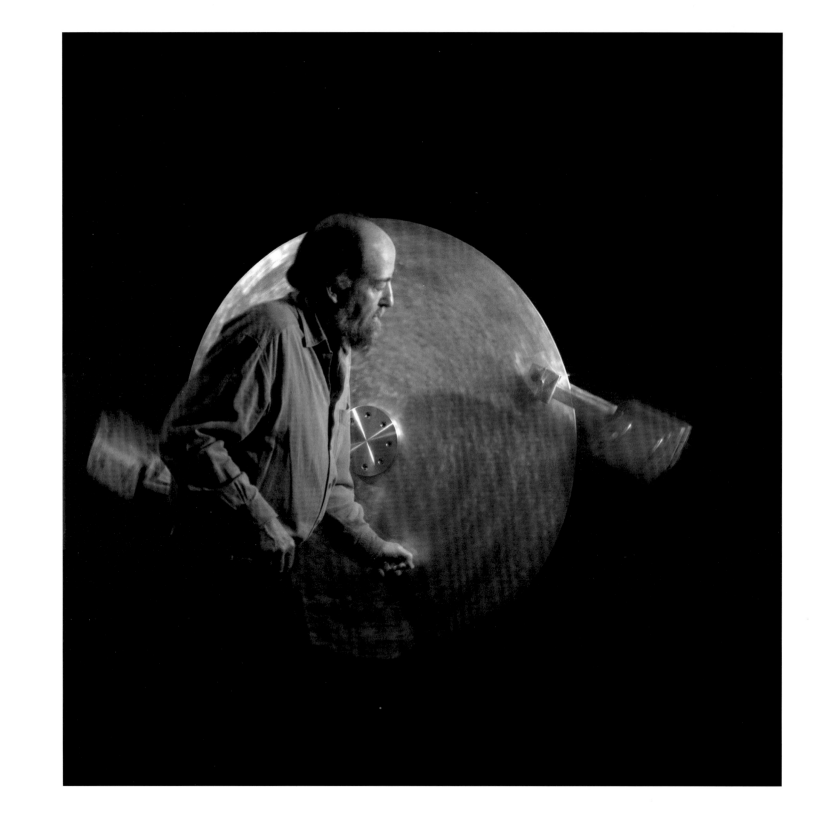

LUIS JIMENEZ

Border Crossing (Cruzando El Rio Bravo), 1989. Fiberglass and urethane finish, 127 x 34 x 54"

JIMENEZ works with an intense social conscience. His vision is clear, direct, and sympathetic to the concerns of the common man. Border Crossing, for example, depicts a young Latino man smuggling his grandmother to a life of greater hope in the North. His sculpture questions the morality of U.S. immigration policy: how can we justify denying to others a prosperity we would fight to defend for ourselves?

Photographed in his New Mexico studio →

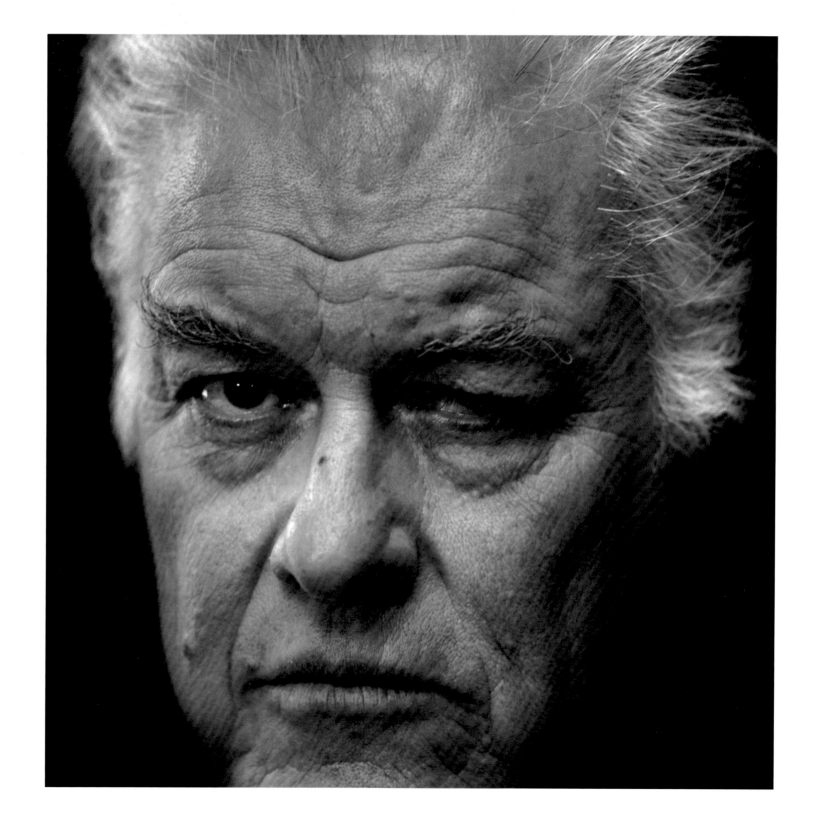

MAGS HARRIES AND LAJOS HÉDER

The Bronx River Golden Ball, 1999, 2000, 2001. (Temporary installation) Fiberglass sphere, gold leaf, canoes, net, mirrors and performers; ball diameter 32"

HARRIES and HÉDER are a husband and wife team who engage public interaction as part of their creative process. Their sculptural installations, integrated into the fabric of the environment in which they are sited, invite onlookers to become participants. In 1999 they floated a gilded ball down the Bronx River, accompanied by community residents who walked ten miles along the shoreline with mirrors reflecting light upon the ball. This celebratory event presented the river's flow as a symbol of interconnectedness between the thousands of residents in adjacent communities. It also helped reveal specific measures which would strengthen the bonds between them. For another installation, they constructed intriguing rest areas along the wooded path of a socially stigmatized park. Motion detectors acknowledged visitors by triggering an audio performance from a hidden sound system. Visitors were enticed to linger and listen. Through their artwork, Harries and Héder created an incentive for the public to repopulate and thus reclaim their park.

Photographed at the Kenduskeag Roots installation in Bangor, Maine

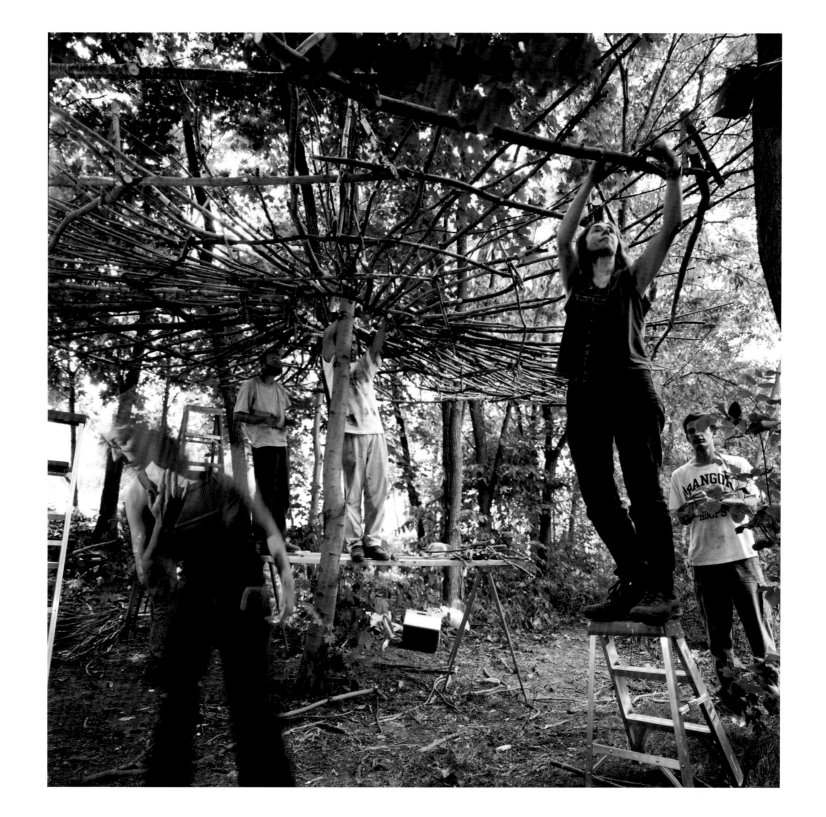

KARL STIRNER

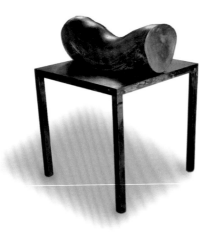

Fleisch auf den Tisch (Flesh/Meat on the Table), 2003. Iron, 34 x 34 x 46"

S T I R N E R makes sculptures remarkable for their irreverent elegance. He often combines pre-formed elements with newly fabricated pieces to create abstract works that boast of an uncertain social status, asymmetrical balance, simplicity, and wit. Some installations use chalk marks, drawn on the floor, to extend the rhythm implied by twisted metal shapes. Stirner is a hearty advocate and patron of the arts. He has been informally referred to as "The Godfather Art in Easton," his Pennsylvania hometown.

Photographed in the courtyard of his Pennsylvania studio →

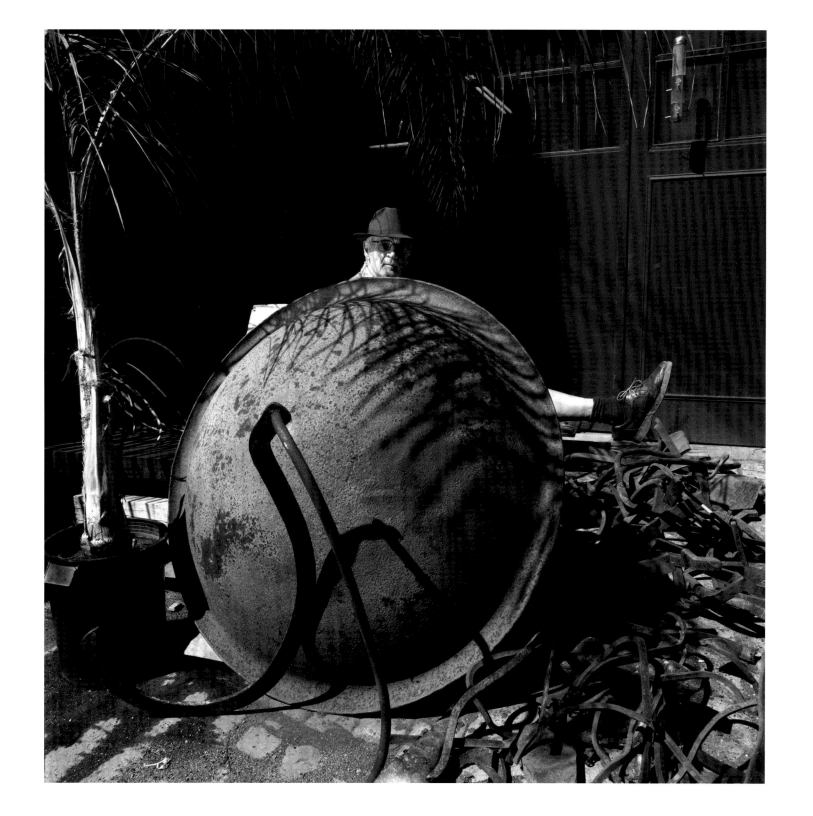

JONATHAN SHAHN

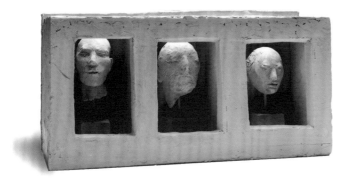

Three Heads in Three Compartments, 1997. Terra cotta, 8 x 15 x 6"

SHAHN is haunted by the possibilities of the portrait – by the features of the face in front of him as well as by faces he carries in his inner vision. He may work on several portraits at once, compelled to move from one to another. With abrupt transitions in his workflow, these portraits are sometimes stranded in an ambiguous state: perhaps finished, perhaps abandoned. Problems and remedies encountered along the way are often incorporated into his evolving composition and may remain in the final presentation. The mausoleum-like plaster boxes isolating his roughly modeled heads, for example, were his solution to the problem of uncontrolled ambient light. These boxes allow him to size and place tailor-made light sources for each of his heads. The confined spaces also reinforce each figure's isolation, and the desiccated surfaces of his materials lend a funereal air to their collective silence. Shahn may give his visions solid form, but he not does take from them their mystery.

Photographed in his New Jersey studio →

82

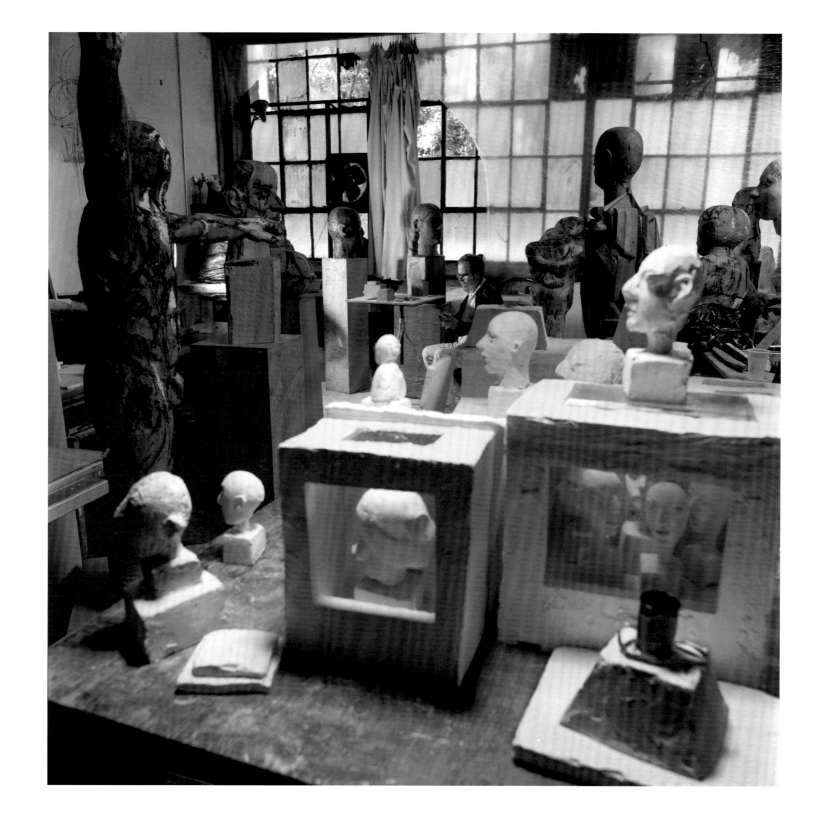

KUKULI VELARDE

Vergüenza, 1999. Slip-cast clay, 22 x 16 x 13"

VELARDE was profoundly moved when she recognized her own features in the face of a Pre-Columbian artwork. This discovery, an act of recognition, incarnated for her the mythical figure, Isichapuitu, from the Peruvian oral tradition. This female, human-like vessel, brings forth spirits from the past. Velarde cast a series of ceramic self-portraits with a common form, and then differentiated each of these castings by hand to tell its individual story and evoke her own spirit. In contrast to the Western notion of separation between Church and State, Velarde's work pulses with the lifeblood of her Latin perspective. She understands that religion, politics, sexuality and art are an integrated whole. We cannot escape their influence; they are fused uniquely in each of us, filtering our personal experience and reinforcing ancestral ties.

Photographed at the Clay Studio in Philadelphia →

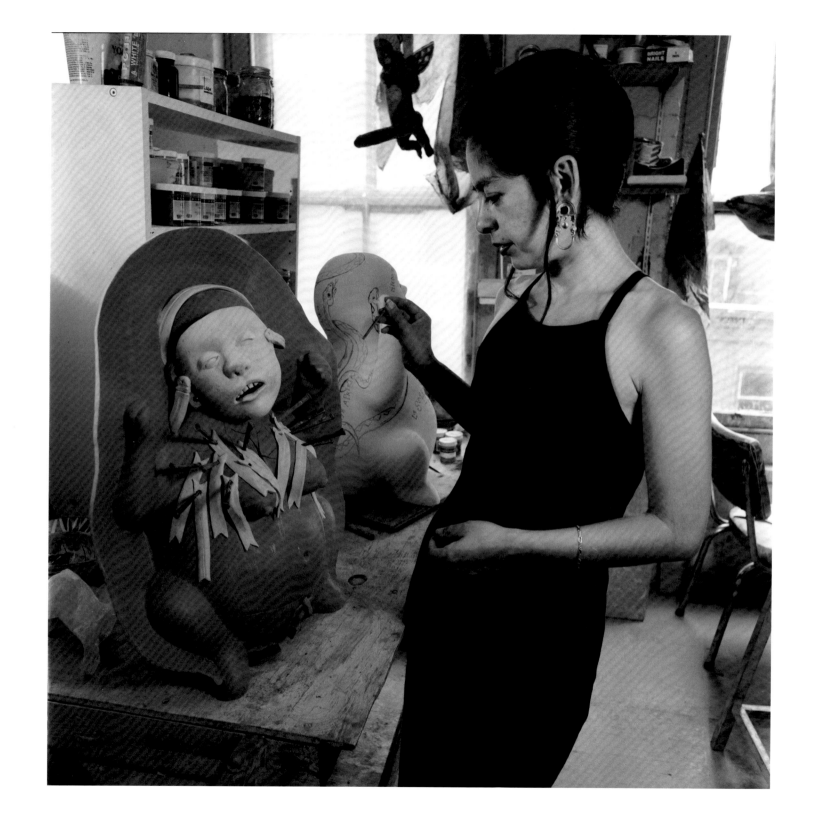

GEORGE GREENAMYER

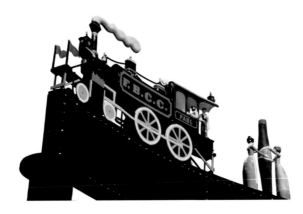

Corning Centennial, 1996. (Detail) Forged, fabricated and painted steel, 179 x 37 x 2"

GREENAMYER, a Quaker blacksmith, is straightforward in his art. What you see is what you get. His pieces express the sensible values of unpretentious, playful, Yankee ingenuity. Figurative and stylistically primitive, each is tailored to the particular site in which it is installed. They are reminiscent of large scale, cast iron piggy banks: colorful, hefty, and frequently mechanized. Which is not to say that they aren't slick. Circling trains narrowly avoid collision with other moving elements, boats bob on saw-tooth waves, and workmen flail tools with industrious purpose. Greenamyer's artwork is readily accessible; his imagination captures public attention and celebrates that which is quintessentially American.

Photographed outside his Massachusetts studio →

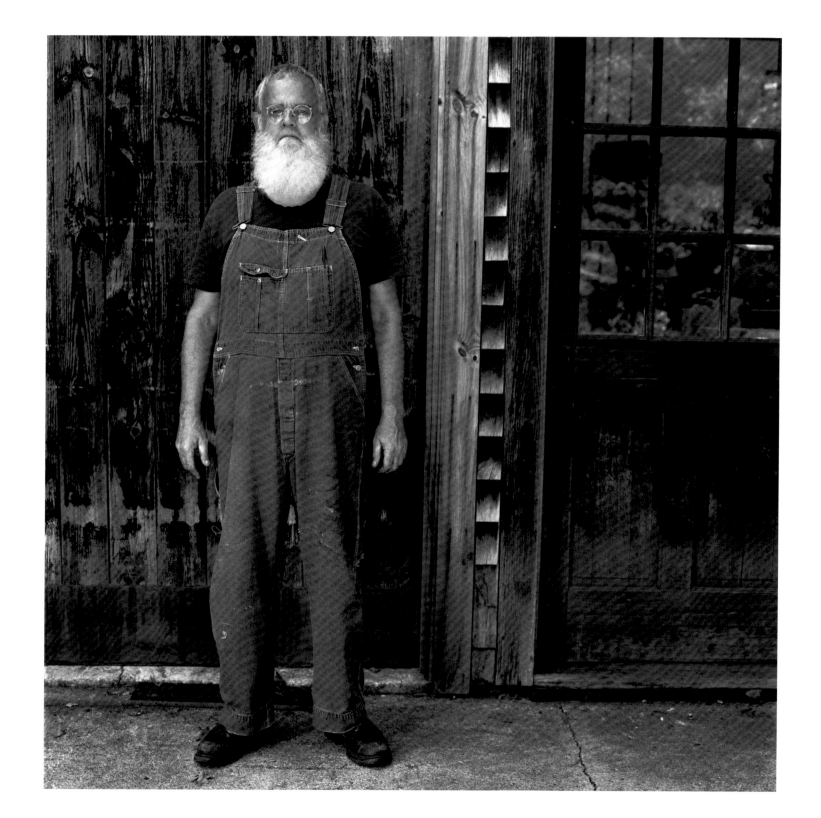

ROBERT LOBE

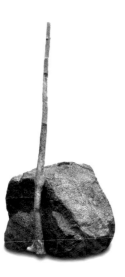

Environmental Impact Statement, 1988. Hammered, anodized aluminum, 24 x 7.5 x 7.5'

L O B E ' S sculptures are literally physical impressions translated into a different context as an expression of his personal observations. Lobe works on his subject matter, actual trees and rocks, in their natural settings. Using a variant of the repoussé technique, in which pliable sheets of metal are hammered against hard surfaces to create a relief of their contours, Lobe sculpturally documents a 360 degree impression for each of his compositions. The multiple impressions are welded into a contiguous whole and transported to a different setting. The industrial materials and processes that Lobe employs accentuate the oddity of his relocated landscapes. Lobe invites viewers to examine more closely the natural world, and to build upon that of his imagination.

Photographed at the Katona Museum, New York

PAT KECK

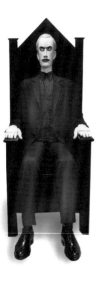

The Watchman, 1987. Painted wood, mixed media, 64 x 25 x 32"

K E C K is a modern day Geppetto, her sculptures Pinocchio's heirs by way of Clockwork Orange. These 'puppets' sport clutches of Keck's own hair and clothing. Formally known as automatons, each asserts a sinister claim to life with limbs driven by motor from deep in their breasts. Each character demands to be addressed independently, and his or her gesture reflects Keck's own subversive sense of humor.

Photographed in her Massachusetts studio →

RANDY JEWART

40,000 Nickles, 2001. 40,000 nickles, approx. 54 x 60 x 4"

JEWART peels back the lid of understanding to reexamine his fundamental purpose in a more universal light. When he had access to a studio, Jewart carved playful, stone monuments. Suggestive of primitive, political-art cartoons, these works tweaked the notions of gravitas, permanence and posterity. Upon relocation and the temporary loss of his studio – and in a period when finances were a timely issue – Jewart turned to performance art. Using other people's money, he stacked 103,520 pennies into towering structures that leaned precariously into space. At the show's end, Jewart brought down the edifices with a golden bowling ball.

Photographed in his studio, Washington, D.C.→

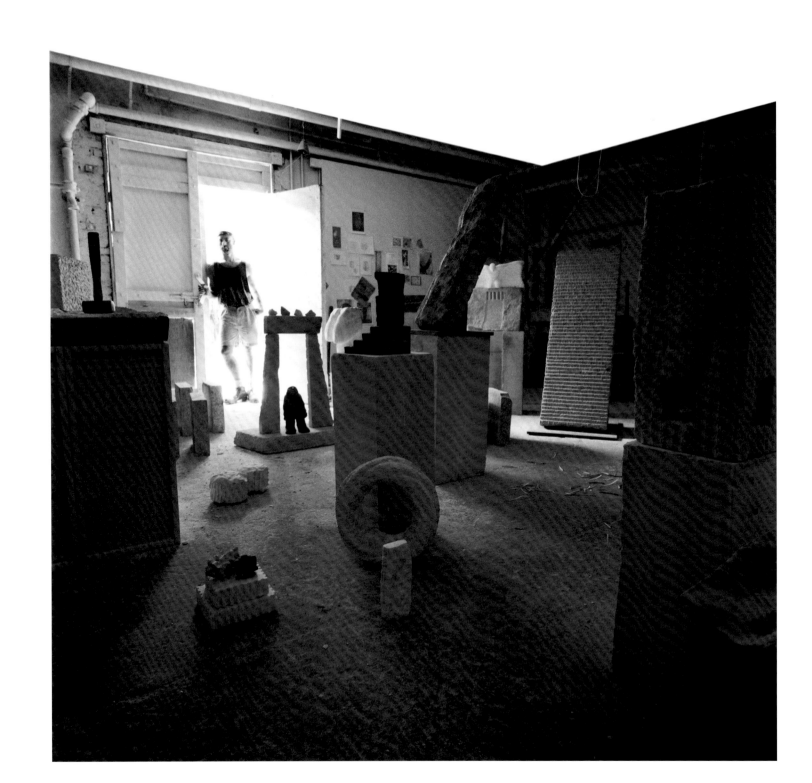

VLADIMIR KANEVSKY

Man with Fish, 1994. Stoneware, oil, 18 x 8 x 6"

KANEVSKY casts much of his sculpture in ceramic, nearly all of it is figurative. He populates his world with loosely autobiographical characters who can barely contain their amiable personalities. With certain features subtly exaggerated, the bodies and gestures of these ceramic figures celebrate common aspects of the human experience. Whether it be a sweet smile, round belly, or the love of one's fish, Kanevsky's ceramic folk gracefully teach us how to accept life's package as a whole.

Photographed at Liberty State Park, New Jersey→

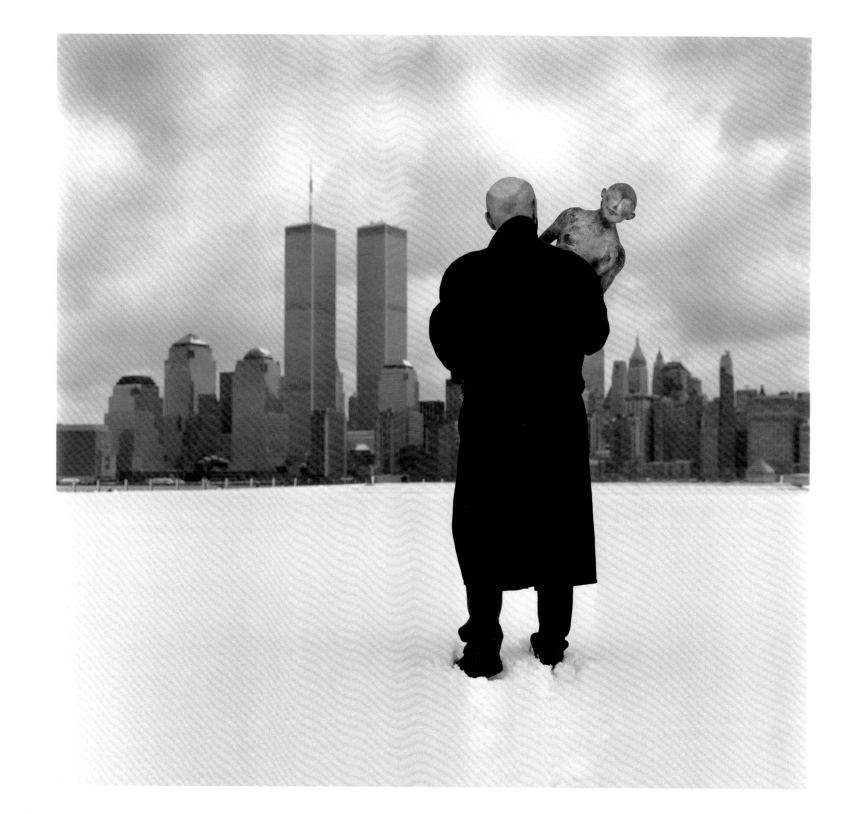

BARRY SNYDER

Mask of the Sower, 1987. Wood, metal, crayon, fabric, 67 x 34 x 3"

SNYDER'S perception of physical objects is unconstrained by the object's function or intended purpose. For Snyder, every object is simply a pre-existing collection of components. Each of these components have more value as a suggestion of what it could be and is not quite yet than as a reminder of what it once was. Coming upon an antique, mechanical seed sower, for example, he disassembled the unit and reconfigured several of its parts. The misfit reassembly may flaunt reason, but it certainly does not lack rhyme. With a light touch and minimal intervention, Snyder's fingers tip the scale to show us his vision of a quirkier, more curious world.

Photographed in his New Jersey studio →

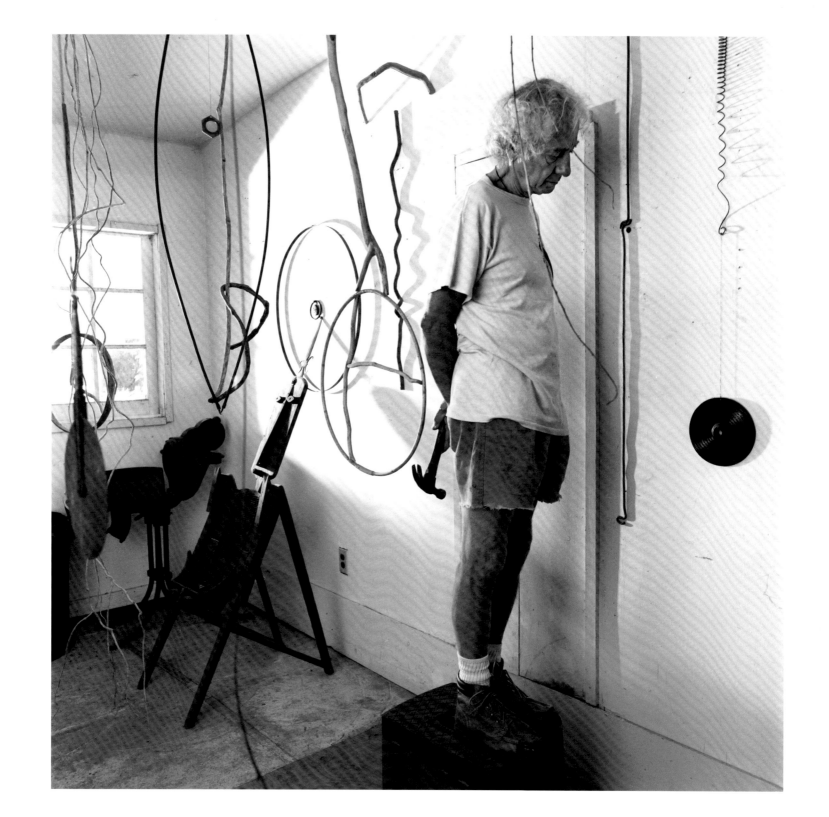

HARRIET CASDIN-SILVER

70 + 1, 1998. (Detail) Three reflection holograms on metal, each 24 x 20"

CASDIN-SILVER has pioneered artistic expression in holography since the 1960's. Rather than focus on inanimate objects, she works primarily with portraits and nudes. Innumerable technical issues make her endeavor a chancy one. Nevertheless, she manages to produce images of frank and startling intimacy. Through these, she challenges social assumptions of beauty and about body image.

Photographed at Center for Holographic Arts in New York City →

MING FAY

Leaf Gate for New York Public School 7, 1994. (Detail, under construction.)
Painted steel, 14' high

FAY is an alchemist gardener, growing natural forms to unnatural sizes in a city environment. His interpretations of fruit, plants, pods and seeds express the vision of a Taoist artist resisting the straight lines and right angles thrust upon urban inhabitants. He has referred to his sculptural installations as celestial gardens. The harvest he shares is less about agriculture than it is about the larger mysteries of life. Fay says: "In Chinese culture, everything has a meaning. ...an orange brings good luck; pears bring prosperity; peaches longevity." We need not know the specific virtue each object represents to understand that every one of his works is laden with larger meaning. Their physical presence re-scales our perception of self-importance. Fay's work tempers our urgency, and we tend to tread lightly upon leaving his garden.

Photographed in his New York loft →

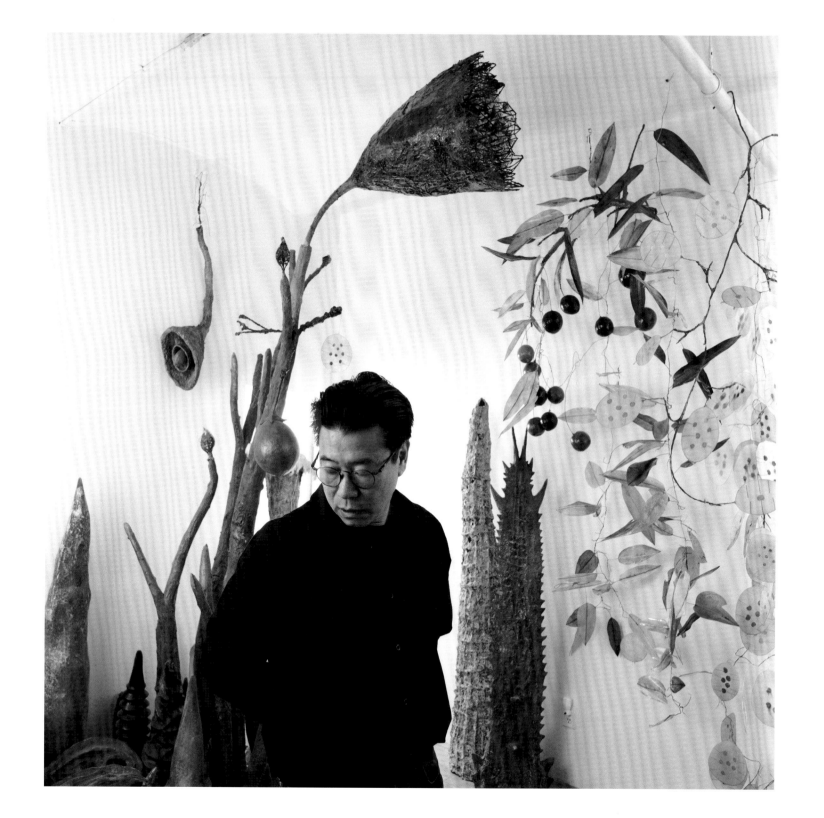

EVE INGALLS

Sheltering Earth, 2002. (Detail) Forton, pigment and steel, 82 x 155 x 145"

INGALLS uses her body as a drawing tool to transcend the boundary separating people from the natural environment. Skin is at the very border of that boundary, and human touch, which bridges that boundary, nurtures our sense of being connected. Ingalls incorporates both tactile sensation and emotional longing into her work by squeezing latex tubes of malleable polymer against her arms and body. The tubes record a physical impression, typically the gesture of an arm wrapped or draped around another person. These shapes harden to become personal documents of intimacy and vulnerability. When assembled into interlocking architectural structures, the individual gestures reinforce one another to suggest interdependency and community. Ingalls tints her forms with organic colors and places her sculpture in the outdoor landscape. The works reflect her yearning for balance and integration with nature.

Photographed in my studio →

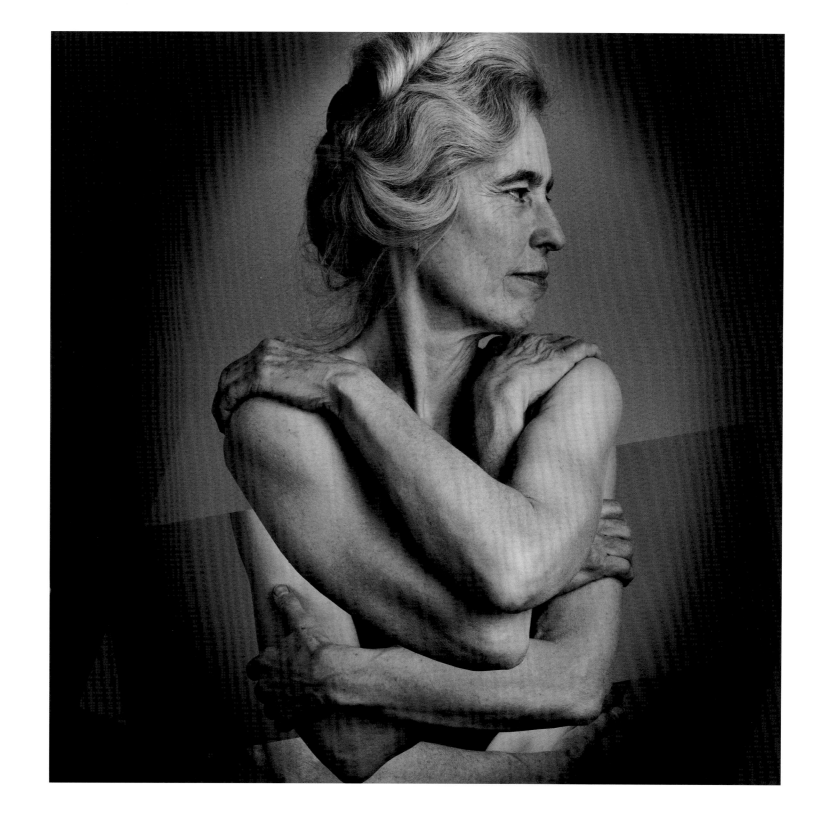

CARLOS DORRIEN

Nine Muses, 1990-1997. Granite, 11 x 20 x 30'

DORRIEN acquired a remote Vermont farm so as to be close to the source of his preferred material, Barre Granite. He carves this stone by hand to varying degrees of refinement. In The Nine Muses, for example, the figures are selectively detailed, smooth in certain areas and rough in others. Their forms are only partially revealed in as many pillars delineating a plaza. It is ambiguous whether the muses are emerging from, or retreating into, the nine columns. This work was inspired, in part, by a stone boundary marker Dorrien found on his Vermont farm.

Photographed with granite boundary marker at his Vermont farm →

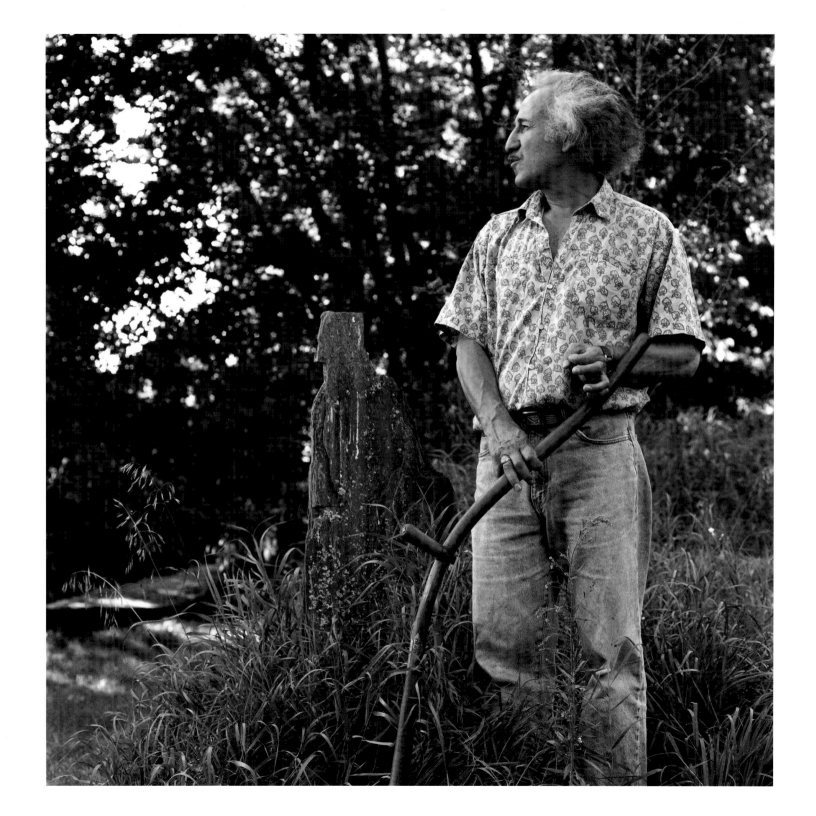

LEONDA FINKE

Standing Figure from Women in the Sun, 1988. Cast bronze, 70 x 33 x 18"

FINKE'S sculpture addresses the inescapable conflicts, turmoil, and passion of the human experience. Working with the figure, she accentuates the drama of her statement explicitly through the gesture suggested by each model's pose, and implicitly through the properties of her sculptural media. The rough, lumpy surfaces of her bronzes offer no respite to the eye. Her works are snapshots of deeply felt emotion, moments captured in a theatrical world where pain and beauty are inseparable.

Photographed on her New York patio →

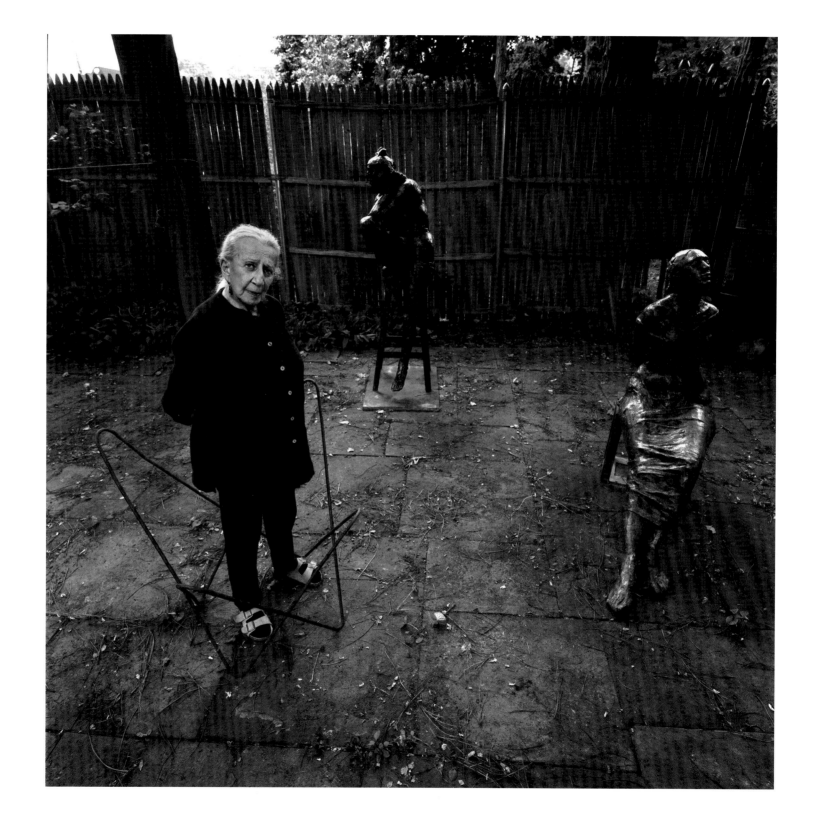

BILL BARRETT

In Search of... (from the Memory Series), 1997. Bronze, 21 x 24 x 10"

BARRETT casts and welds his sculpture. Though gently rounded, the edges of Barrett's sculpture carve intricate forms exploring the relationship between positive and negative space. These forms have been likened to the calligraphic strokes of a musical score, with each element reflecting the strength of the gesture from which it was born. If sculpture has a tempo, Barrett's is allegro.

Photographed at Grounds For Sculpture, New Jersey →

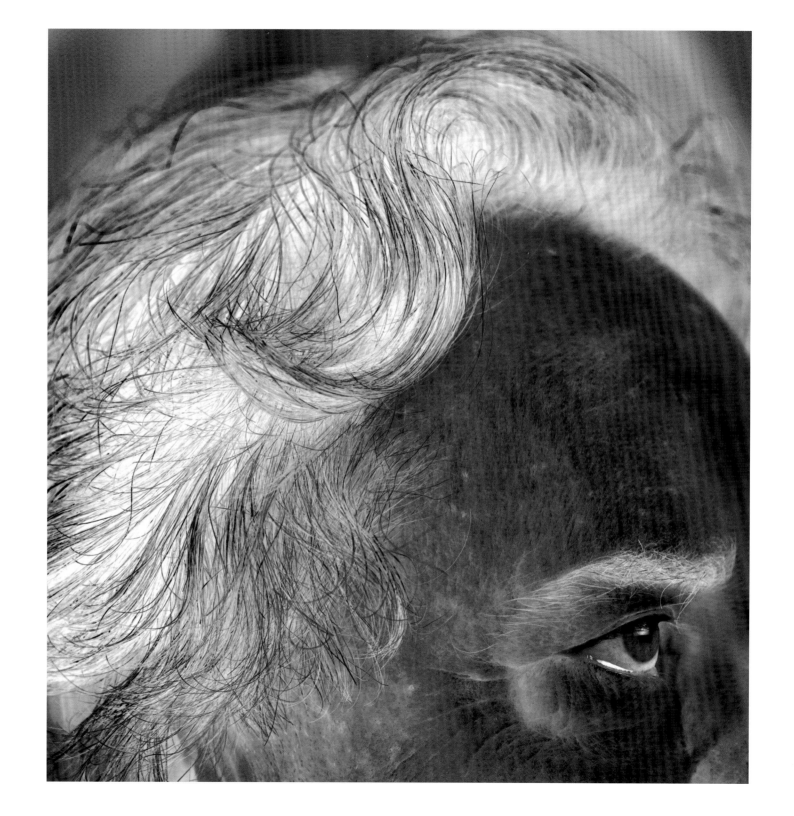

KEN HRUBY

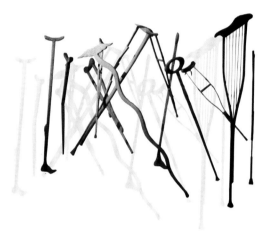

Minefields of Memory, 1997. (Detail) Poplar, rice, abrasive, metal filings, mixed woods, motors, magnets and mechanics; Three modules, 12 x 4 x 11', variable configurations

H R U B Y is a rare creature within the community of artists. His work is certainly unique, but the path he took to join their number is most unusual. Hruby is a retired US Army Colonel. "My friends in the Army thought I was on the radical left," he says, "and my friends in the art world think I'm a right-wing conservative." Hruby's work addresses the consequences of the techno-mythology associated with the military institution. And his sculptural war stories can be merciless. In Minefields of Memory, for example, he suspended an array of hand-made crutches from string so they might clack like bone-dry marionettes in the breeze. This is a sculpture imbued with personal experience. When a young soldier in Korea, Hruby laid a minefield. Years later, charged with the responsibility of removing the mines, he was dumbfounded to discover that the mines had seemingly migrated. He did not find them, and the task could not be completed. Every memory is fallible; this sculpture is a metaphor for one haunted by undetonated explosives.

Photographed with Free Fall in his Boston studio →

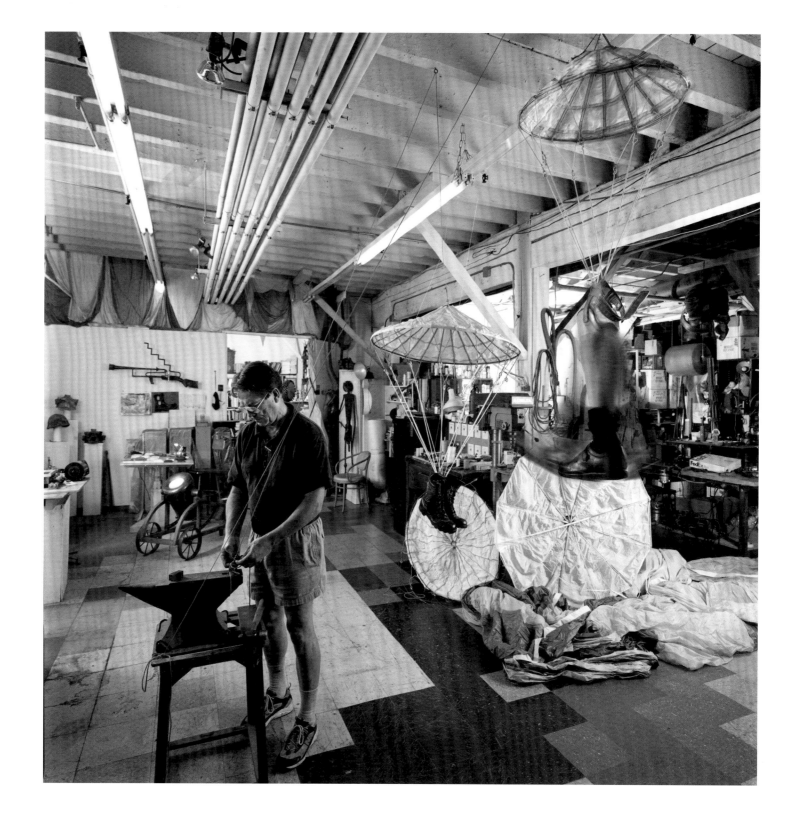

JOHN GOODYEAR

Lunching Out, 1980. Acrylic on canvass and wood, 36 x 108 x 6"

GOODYEAR'S sculptures are often kinetic and exploit the space fleetingly visible in between the work's physical elements. Typically, a pendulum-like grid is suspended in front of a rear panel. As the pendulum swings left and right, the grid alternately conceals and reveals detail in the background. Strategic alignment of shapes and color in the near and far planes entice viewer interpretation of a continuous image, with the resultant effect of a mesmerizing presentation.

Photographed with Hand Stand outside his New Jersey studio →

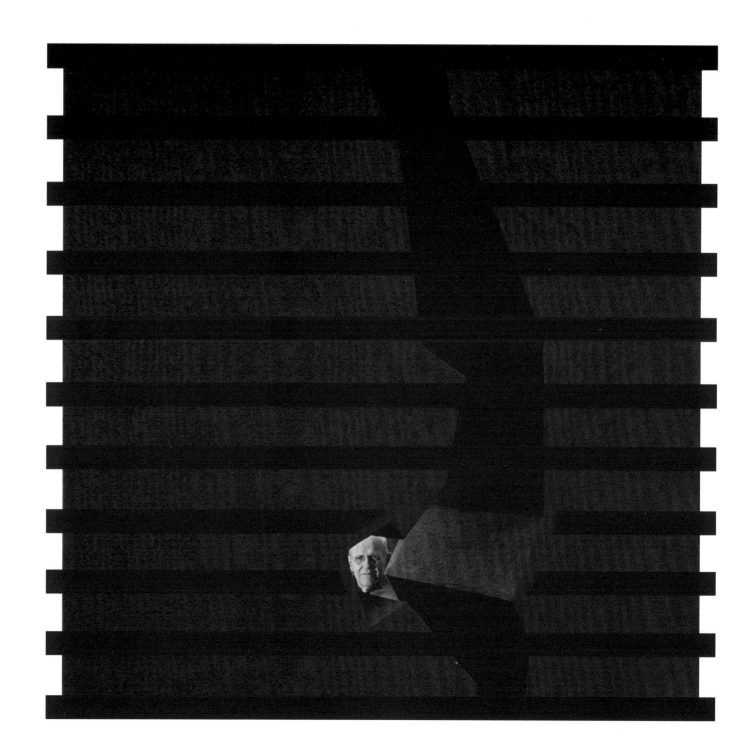

DESSA KIRK

Red Lilly, 1998. Cadillac cars, 144 x 96 x 96"

KIRK'S artwork is rooted in two mainstays of American culture: cars and sex. Drawing her inspiration from an older profession, this sculptor carves up Cadillacs – "pimp mobiles" as she calls them – refashioning the vehicles into flowers for an industrial-strength garden. Her pieces sprout into large-scale flowers whose pounded and welded metal petals speak plainly of their automotive origins. Full, red lips separated from the women to whom they belong, cluster with anticipation in a precarious balance. Long-legged stems often mimic a provocative stance. Thus Kirk inverts an age-old relationship by fashioning homages to feminine strength from the scrapped metal symbols of the power and luxury that kept these women down. When Kirk gardens the street, blossoms are most resilient.

Photographed outside her Chicago studio →

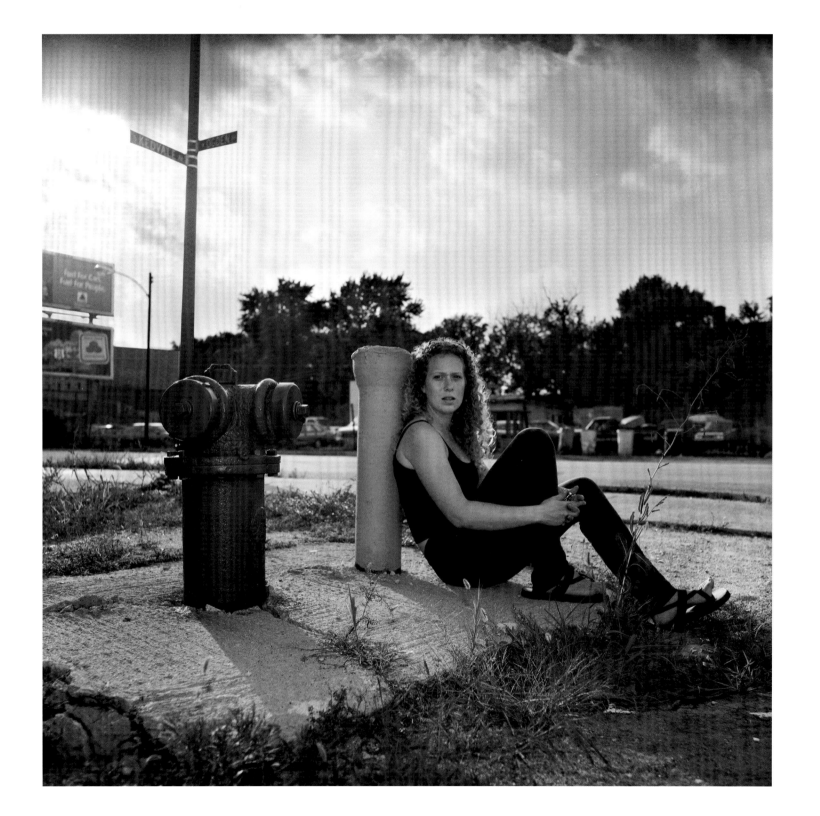

KONSTANTIN SIMUN

King, Queen and Myself, 1988-1991. Wooden chairs, 39 x 44 x 21"

Since immigrating to this country from Russia in 1988, where he is best known for more conventional public monuments, S I M U N has mined the creative possibilities of discarded materials. Clorox bottles are but one example. Simun demonstrates that these empty containers are trash only if they arrive at and stay in the dump. In his hands, after a few snips with a sharp pair of scissors, spent Clorox bottles metamorphose into new entities and acquire a newfound charm. Broadly speaking, Simun asserts in his sculpture that neither artwork nor the Art Spirit need be separated from our daily routine. His pieces invite us to reconsider our definition of waste, the opportunity for redemption, and our ecological responsibilities. The Romans may have carved stone with an eye towards eternity; Simun knows that polyethylene will last longer.

Photographed at his Massachusetts home
→

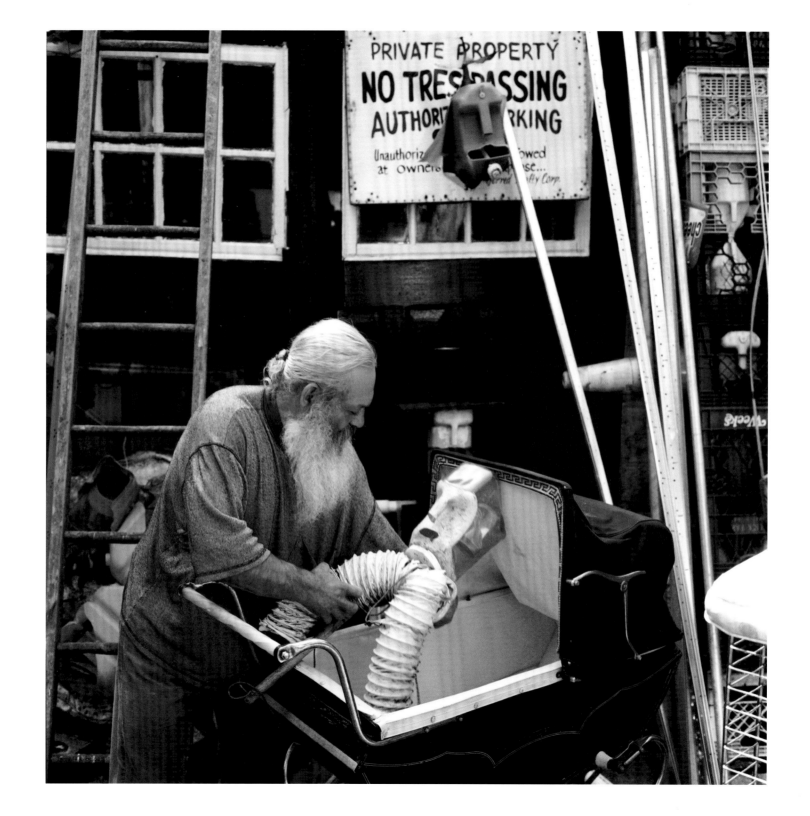

TOSHIKO TAKAEZU

Li-Mu (Seaweed), 1993. Glazed stoneware, 63 x 26 x 26"

TAKAEZU brings artwork forth from the center of her being, Zen like and at one with her craft. The beauty in her ceramic work resides at an intangible core where process and product are inseparable. Peeling back opportunities for adornment, she relinquishes control to the clay and to her glaze-laden brushes. She delves into the place where tranquility and acceptance overwhelm the relevance of self-expression. Takaezu was the first ceramist to create closed form, ceramic vessels, shedding all vestiges of pottery's implicit ties to functional use. The unseen, internal spaces are important to Takaezu. When the pieces are moved, rare as such occasions might be for a six-foot high pot, a small bead of clay rattles inside. It is Takaezu's reminder that there is more to beauty than what meets the eye.

Photographed in her New Jersey home →

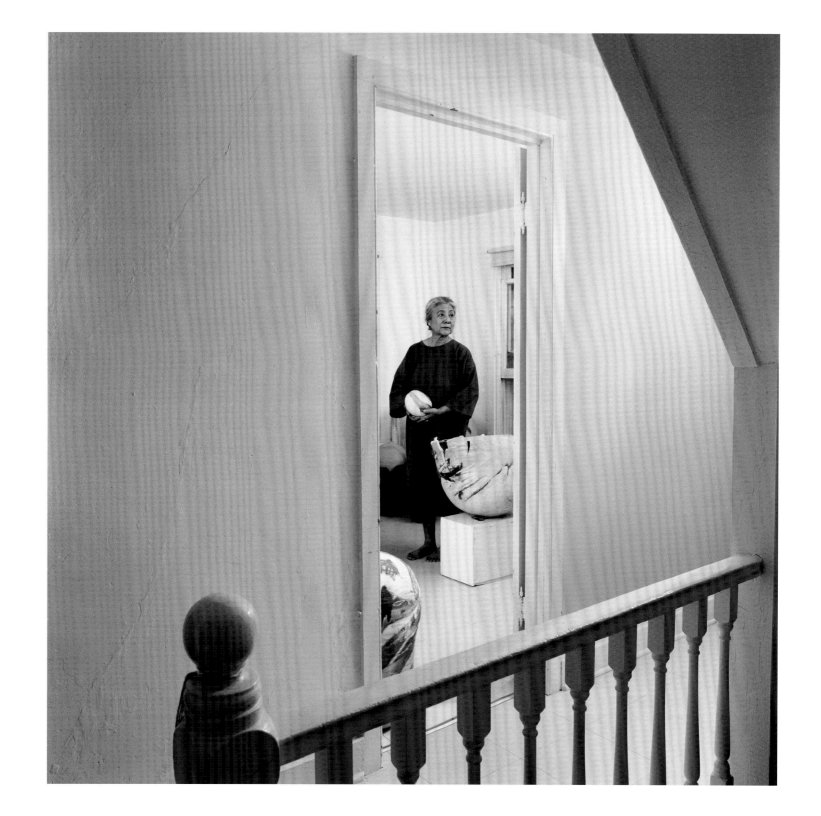

ANNEE SPILEOS SCOTT

Bloodlines: Remembering Smyrna, 1922. Mixed Media installation with sound, 25 x 25 x 12'

SPILEOS SCOTT creates highly personal installations addressing the turmoil and dysfunction that can reverberate for generations when an atrocity is visited upon a family. In Bloodlines: Remembering Smyrna, 1922, honoring Greek and Armenian genocide victims, she flooded a museum floor with personal artifacts of the deceased. Spileos Scott's installation recreated the carnage visible to armed sailors from an international armada who safely witnessed the horrific event from their ships in the harbor

Photographed in her installation Bloodlines: Remembering Smyrna, 1922, at the Fuller Museum of Art, Massachusetts →

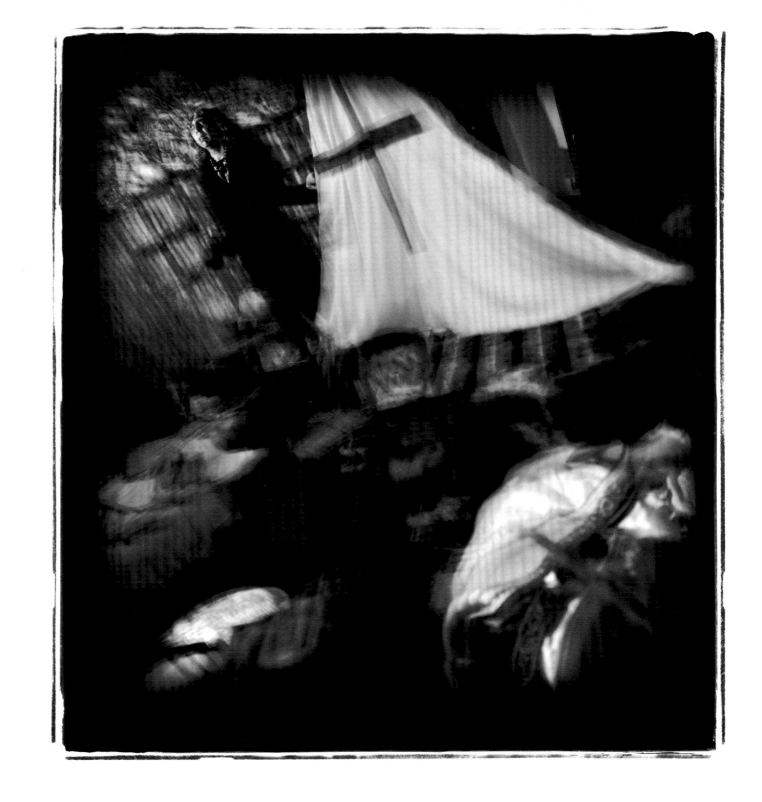

PETER STEMPEL

Sparkle, 2002. (Maquette.) Ceramic tile and wire, approx. 12 x 30"

STEMPEL appropriates the space in-between and surrounding his sculpture. He playfully directs attention away from the object-like qualities of Art and towards the environment enveloping both his sculpture and the viewer. Individual elements are often replicated in his work, and the sculpture itself can take many forms. These include colorful holes in the ground – he is lying inside one of his Conoids, a submerged, bisected cylinder, in the image at right – and a ceramic tile carpet draped to reflect undulations in the countryside. With enhanced sensitivity to the interstices, he seeks to forge an intimate connection between physical bodies and the landscapes in which they reside.

Photographed with Conoids at Roger Williams Park, Rhode Island →

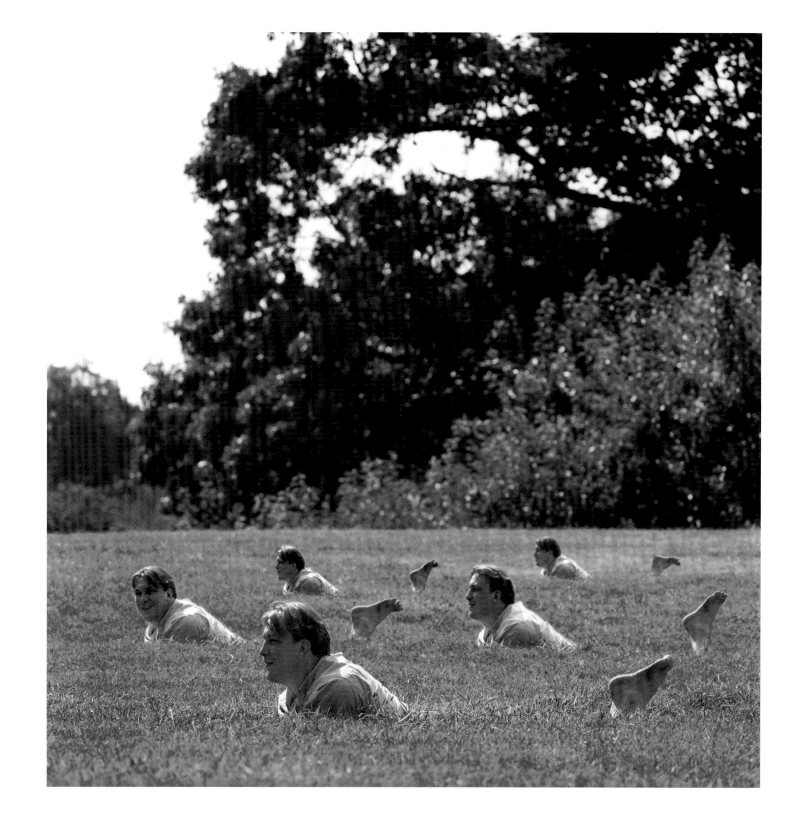

MARISOL

Mi Mama y Yo, 1968. Bronze and steel, 80 x 56 x 56"

MARISOL sculpts highly observant portraits that make astute social and political comment, yet they are seen through a childlike eye. General Bronze is her 'anti-monument' portrait of the South American dictator, General Gomez. Only his face, that of his horse, and his hands are rendered with texture. The horse's body is also a secret sarcophagus and, visible through a discreet portal by the tail, is the dictator's scepter and death mask inside the animal's chest.

Photographed with General Bronze at the Johnson Atelier in New Jersey →

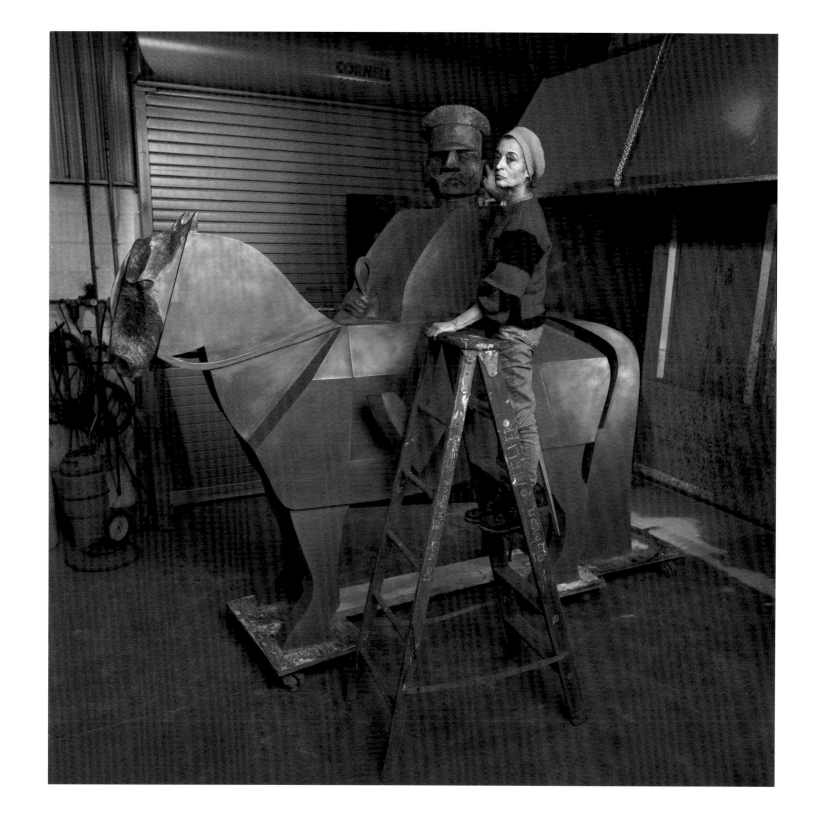

ARTHUR GANSON

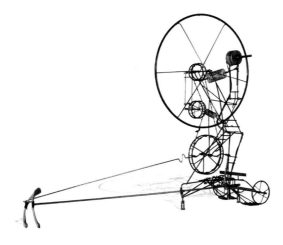

Machine with Wishbone, 1988. Steel wire, motor, chicken wishbone, 16 x 20 x 6"

G A N S O N ' S sculptures are handmade, playful, often delicate and complex working machines that intrigue viewer interest by virtue of their near-pointless machination. His works are unabashed contraptions, glorious solutions to invented challenges. At the conceptual core of Ganson's machines is a counterpart human gesture. By detailing the complexities involved with even the simplest of movements, Ganson's sculpture separates viewers from their expectation of purpose. The question of "Why?" is overwhelmed by the cleverness Ganson demonstrates in "How?" Our own curiosity becomes another tool in Ganson's kit, seducing us to find unexpected kinship with his machines.

Photographed in his Massachusetts studio →

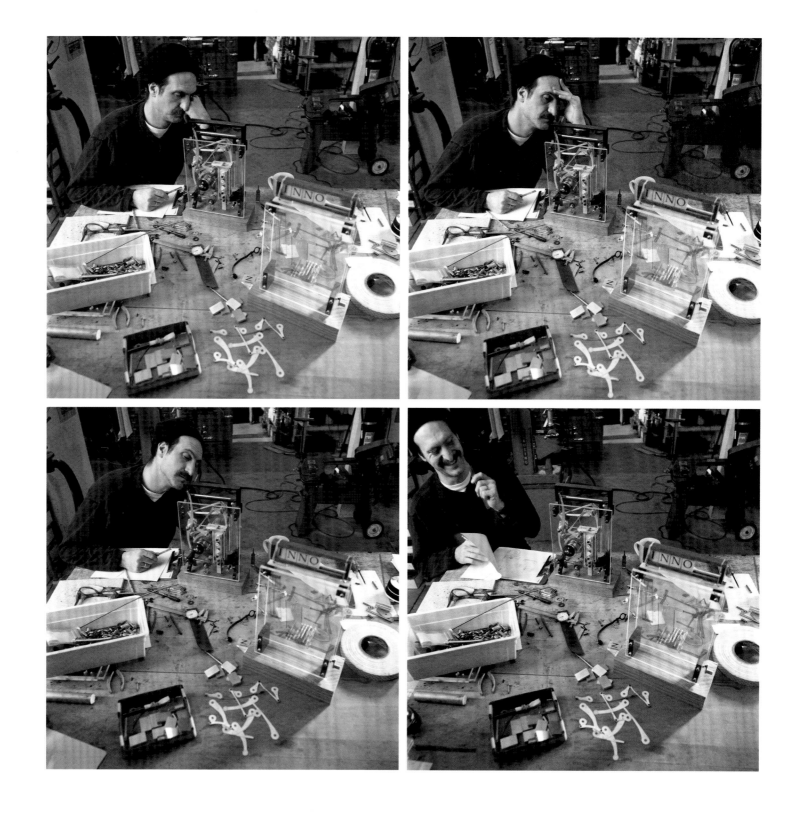

ISAAC WITKIN

Transfiguration, 1997. Bronze, 125 x 80 x 54"

Sculptural processes can be a means as well as a source for creative expression. In the traditional casting process, molten bronze is poured into the cavity of a stiffened mold and assumes the mold's shape upon cooling. The cast is a realization of a previsualized form. W I T K I N liberated this process by pouring molten metal directly into a bed of unconstrained, loose sand. He 'drew' with the stream as molten metal poured from the ladle to run its course and harden where it lay. In solid form, Witkin discovered, the hardened bronze retained the grace and fluidity of the molten stream. He uses these fluid shapes as the point of departure for larger, traditionally cast works.

Photographed at his New Jersey studio →

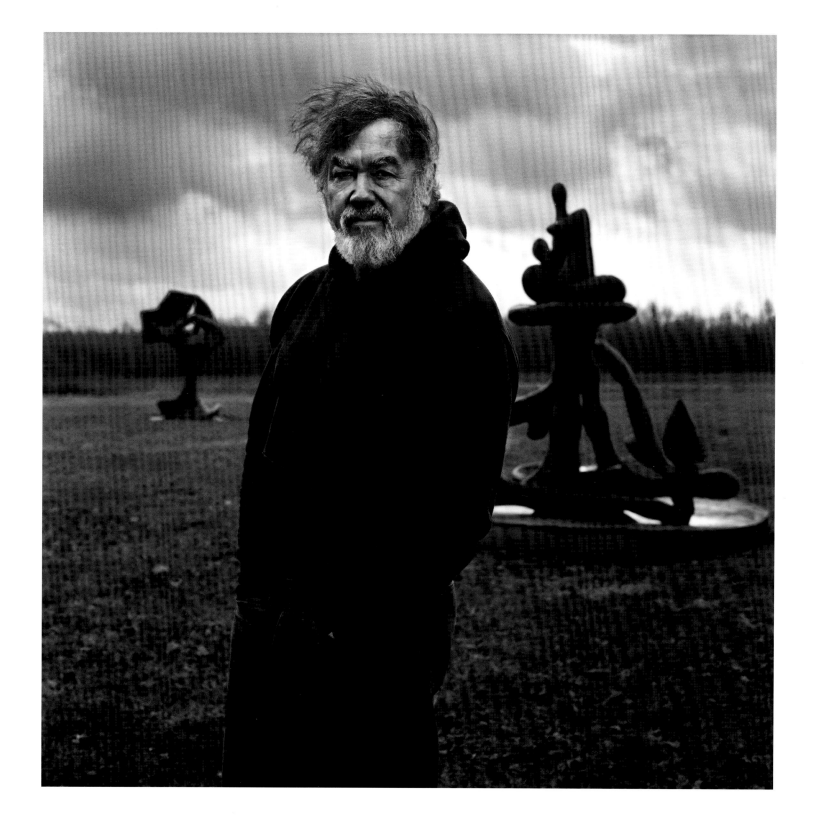

MARTHA POSNER

Torso with Wing, 1999. Wire fence, bees wax, synthetic hair and feathers, 37 x 44 x 25"

POSNER revisits myths, both traditional and contemporary, to find core themes that resonate with her own experience. With a highly personal interpretation, she re-expresses these stories using organic sculptural materials, oftentimes thorns, feathers, beeswax, and wool. Her translation of myths from the oral tradition to an unconventional physical form creates new opportunities for us to assess the values these legends engender.

Photographed with Torso with Wing in her Pennsylvania studio →

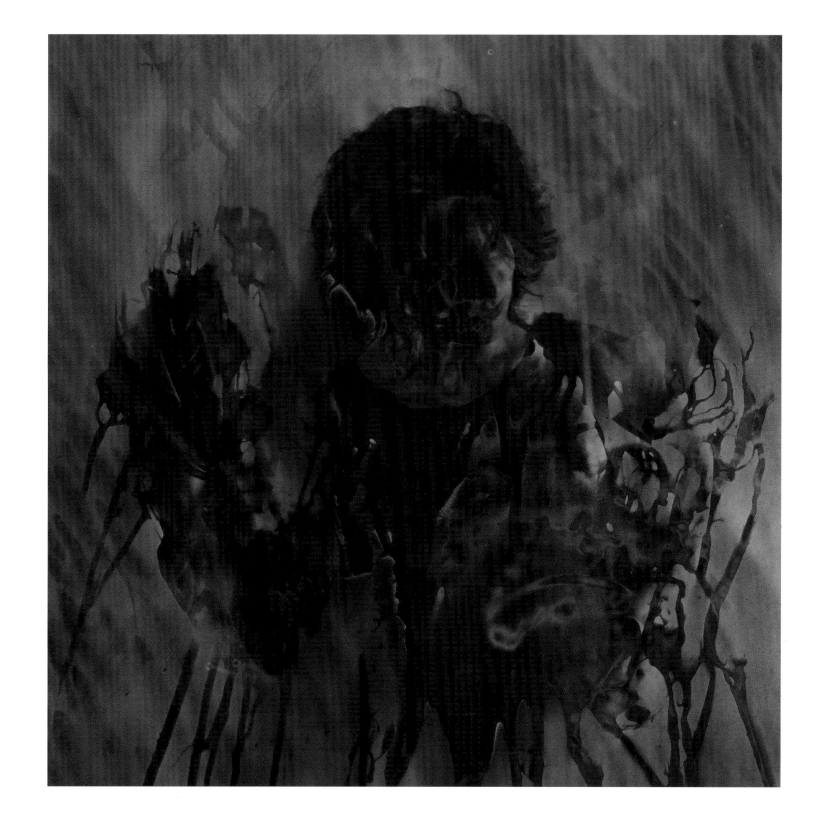

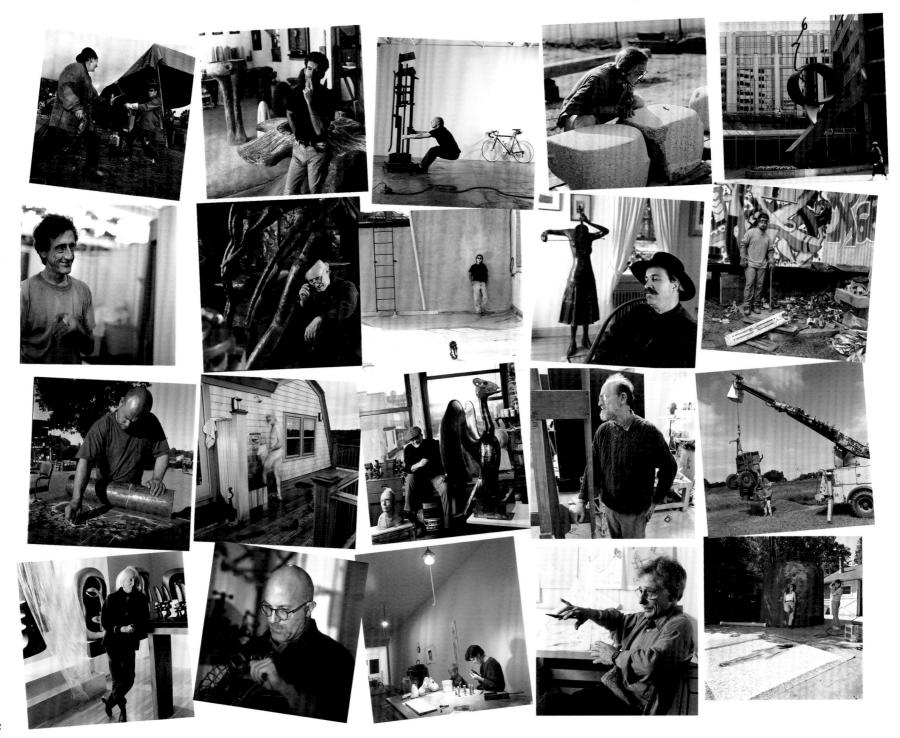

PHOTOGRAPHER'S AFTERWORD:

WHY SCULPTORS?

WHY SCULPTORS?

This is the question I'm most frequently asked about this body of work. The short answer is that I photograph sculpture professionally. While this answer satisfies many people, I know that circumstance and opportunity do not explain motivation. The longer answer is necessarily more complex. It involves my interest in art and my respect for the individual spirit. What I came to appreciate is that the portrait-making process fused my interests and became a vehicle not only for the expression of identity but also for an extended inquiry into the creative process itself.

When I made my very first sculptor portrait, in 1995, I hadn't any notion that my involvement would extend beyond a few hours' effort. Caroline Gibson stopped by one evening with work for me to photograph. It was the first time we met, and I had agreed to help her promote an upcoming exhibit. Somewhat casually we created a makeshift studio in my living room. As we began to photograph an unexpected momentum built. She continuously brought out new pieces, and I kept pace by unpacking more equipment. Soon, we had cluttered all of our space with both art and camera gear. I shot more film than we had intended and in ways that she didn't need. My compositions began to include more of Caroline and only much later did I realize we had a portrait. I remember feeling oddly successful when we finished that evening. I had thought I was photographing for Caroline, but I had produced images that were for me, too.

Cover, p22

The following year, I was contracted to photograph Isaac Witkin at work in his stu- *p128*
dio. The light was beautiful when I arrived – fast-moving, storm gray clouds pulled
the sky close to the field we stood in. Isaac indulged my request to take a few pic-
tures outside. I remember feeling rushed, both because of the changing light and
because there was real work waiting to be done. I quickly set up one portable flash
and raced through a roll of twelve shots. The last of these images practically
jumped off the contact sheet when I proofed it. Isaac had been transported to a
distant countryside, and from there his stare pierced the distance straight back
through the lens and into me.

A few months later I was commissioned to photograph Marisol putting *p124*
the finishing touches on her sculpture, *General Bronze*. She was hours late in arriv-
ing, and I grew apprehensive. When Marisol finally arrived, there was little dan-
ger of wasting time in conversation. We started working immediately. Fifteen min-
utes later, quite unexpectedly, in a courteous but plainly worded request, she let
me know that the shoot was over. I packed up my equipment hoping I might have
just one good picture for my assignment. I was relieved to discover I did, although
the best picture was not about sculpture or the sculpture making process. The best
picture was about the intensity of Marisol's expression. It was about something I
saw in the person I met.

The following winter Magdalena Abakanowicz visited Grounds For *p18, 145*
Sculpture for the first time. She was there to site one of her pieces, and I was hired
to document her visit. I followed her entourage and photographed discreetly as
she walked through the park. It was not appropriate for me to interact directly
with the group, and especially not with Magdalena, so I had modest expectations
of the pictures I was making. When I printed the contact sheets from that day, my
first reaction was disappointment. It took nearly two years for me to reconcile the
images I had with my response to Magdalena's work. This reconciliation required
that I reintroduce myself into the photographic experience.

All of these experiences, enlightening though they may have been, were incidental to where I wanted to go. I thought of myself as a landscape photographer when these portraits were made. My landscapes, most recently of the West, rarely included people. Brooke Barrie, Director at Grounds For Sculpture, invited me to show her my portfolio. She was interested in exhibiting photographs, but the landscapes were not appropriate to her mission. We discussed other possibilities and quickly converged upon the early portraits I had already made. The fit was perfect. These were aesthetically self-sufficient photographs whose subject happened to be sculptors. The portraits could be presented as an end unto themselves and in conjunction with an independent exhibit of sculpture. Brooke invited me to exhibit a collection of sculptor portraits at her museum the following year.

There was one small problem. I had committed to a one-man show in a significant museum with relatively little time to prepare, and I was twenty-five photographs shy of an exhibition. The balance of this show – if not the body – did not exist. With some urgency, I studied my early portraits for hints as to how I might increase their number.

I think most people naturally expect a cohesive vision will flow through each of the individual works in a portfolio. If so, my portrait portfolio was already in trouble. Each of my pictures was different. It was difficult to see what made these portraits similar. It wasn't clear that only one photographer made them all, and since that photographer was me, I knew that even I wasn't sure what my 'vision' really was.

Equally problematic for me was the nature of each portrait's success. With a finished print in hand, I can say a lot about why or how a photograph works, but truthfully, these pictures were unplanned. As I exposed my film, I had little idea about what would happen next. I was so immersed in the moment, I may as well have directed my shots into the dark. Somehow, with these portraits, the shots found a bull's-eye. My concern was that the bull's-eye they hit was one I

Approaching Storm, Ghost Ranch, NM, 1995

hadn't actually seen, let alone aimed for. This raised the question of whether a success achieved when the author is not in control can be reproduced, and also whether I was responsible for these successes at all.

I eventually realized that these observations prescribed guidelines for the artistic vision I was about to develop. My approach became one in which each portrait is *supposed* to be different. Rather than have one visual treatment applied to every sitter, my approach calls for a *diversity* of treatments. This project created for me an opportunity to sample all the photographic medium's corners and to choose from a range of expressive styles. I would make creative and technical decisions where and when they were most appropriate – on a portrait by portrait basis. In so doing I hoped that my portraits would resonate with my subjects in form as well as in intent.

I also discovered how to shoot at unseen targets. The key was to set up the right initial conditions. I had to avoid thinking about what I would do in a session before I got to the shoot location. I needed to see my subjects as they were at that moment, acutely in the present tense. It was critical that I create space for a shared experience. I didn't want my sitters to posture or present a rehearsed performance, and I had to be willing to go where they might want to take me. I had to be willing to surrender control. I realized that the best pointers to an interesting image would be provided by an unsuspecting guide, the sculptor, and that he or she would lead me there by indirect means. Even when I had an initial idea for a portrait, it often was the second or third image, inspired by Polaroid proofs as we went along, that ultimately was the most rewarding. The portrait sessions became playful adventures.

Finding sculptors to photograph was not difficult. I interact with sculptors on a weekly basis through professional contact with museums, galleries and individual artists. My initial selection was based on my personal assessment of a sculptor's passion, commitment and accomplishment. Because my own disposition was heavily biased towards the first of these three, and because I was not a good

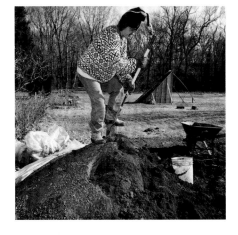

Tim Lefens working on frozen, rammed earth sculpture

judge of the second two, I turned to established experts for help. I invited curators to refer sculptors they felt appropriate for me to include. I received names in batches. Each batch tended to reflect that curator's taste, and the batches spanned a broad range of artistic styles. While I hadn't thought of it as such, mine became a non-denominational project that reached far and wide. My network also grew because sculptors suggested the names of colleagues. With all of these referrals, I was stunned to learn how broad the field of sculpture has become.

Contemporary sculpture encompasses far more than artists working in clay, metal, stone and wood. Sculptors work with glass, rubber, plastic, fiberglass, fabric, recycled materials and found objects. The sculptures involve light, music, performance and public interaction. They can be abstract, representational or conceptual. Some sculptures are objects, others are installations. Some are lasting while others are ephemeral. And so on.

Fortunately, my interest lay in portraiture and not in a survey of contemporary sculpture. Still, I wanted a diversity of work represented, so I settled on my own, inclusive definition. I defined a sculptor to be any person who actively engages the third dimension in at least part of his or her work.

I was able to mount a thirty-six portrait show at Grounds for Sculpture in 1998. One year later, I exhibited twenty-four new portraits at Marsha Child Contemporary, in Princeton. The public response to my work in both of these shows surprised me, not because of the positive assessment of the work for which I was thankful, but because viewers were able to develop an interest in images of strangers about whom they knew very little. Encouraged, I continued to make new pictures. I have taken more than 100 portraits to date and the portfolio continues to grow.

I'd like to think that these portraits reach beyond the photographic realm. Their substance derives from my relationship with the sculptors when I photographed them as well as from my response to their work. Perhaps a few stories might suggest the nature of these connections.

Photographing MARTHA POSNER

Martha Posner lives on a farm with an odd menagerie of pets. Among them are goats, sheep, an emu, rabbits, geese, chickens, a dog, peacocks, and the occasional deer. She calls them by name. Caring for them is at the core of her daily routine so it's not surprising that they're also present in her artwork. She makes sculpture with an armature of wire mesh fence, the type used by farmers to pen animals, and upon this she layers a membrane of beeswax, horse hair, fleece and feathers. Despite their earthy, organic make up, in form Martha's sculptures resemble apparitions at the far edge of a dream.

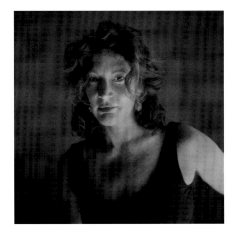

Martha Posner in goat shed

I was compelled to photograph Martha twice. The first time we made several good images, some including her work and others with more emphasis on the environment. My favorite of these was the image we made in a goat shed before Leon, a four-legged Nubian friend, abruptly evicted us. It is a simple portrait, with Martha looking directly into the lens, and it shows her to be blessed with a farmer's lack of pretension. Later she showed me her paintings.

Martha paints watercolors. As we flipped through a stack of these, we got to one in which the colors bled down the paper as I had seen no watercolor ever bleed before. I studied the image and she explained:

"Well, I started out with finished painting. Then I held it under a running faucet and watched the colors streak. I wasn't afraid to risk losing the painting on the chance that I could make it better."

At that moment, Martha raised my standards for artistic integrity. High standards can be frustrating. I knew something was missing from her portrait when I studied the proofs in my darkroom. My images were too safe. I had been seduced by beauty and failed to capture courage. With some embarrassment, I asked if I could photograph her again.

The second time I photographed Martha she was holding a handful of feathers and sticking them, like darts, into the wax membrane of a sculpture. It was

p130

a simple composition, more direct but not too different from what I previously had. In all respects this was a conventional negative. I then committed to producing a print that resonated with Martha's own work.

To make this print I used a destructive bleach and redevelopment technique. The procedure is difficult to control and the specific results are not reproducible. What I did beyond that, however, was to hold my print at a near vertical angle and use a developer-drenched paper towel instead of a tray. I dabbed, dripped and whipped developer onto the print's surface. Only those parts of the print that I moistened were able to reveal the latent image. Naturally, streaks of developer coursed irregularly downwards with gravity to bring out parts of the image below. The edges of these development streaks defined new boundaries and left conspicuous voids. With the underlying forms clearly delineated but ambiguously defined, this treatment created a visual twilight and allowed Martha to join her sculpture on its ghostly edge.

Photographing GEORGE SEGAL

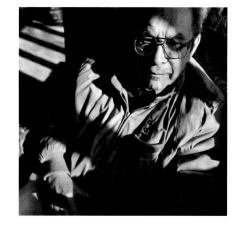

George Segal in easy chair

George Segal was a very busy man when I called to request a portrait session. He asked that I stop in before the shoot, scout his studio and return the following day to produce my portrait more efficiently.

George's studio is an ex-chicken coop. It is a long, simple structure with a slanted roof and an extended row of windows along one side. It had many charms but in November, heat wasn't one of them. Our first meeting was brief, and I returned the next day as we had planned.

As we began to set up the first shot, George grew intrigued by my equipment. He had an interest in photography and this opened up our conversation. We talked about making a living as an artist, and he said that he found public commissions difficult because too many decisions involved the committee process.

p48

We also talked about artistic development. It takes time, he said, but what is really important is that one's own work be relevant to one's own life. At that time George, already into his seventies, confided that he was "middle aging."

When he described the evolution of his interests, my thoughts returned to this comment. When he first started to drape wet plaster bandages on live models in the sixties, his initial desire had been to capture the suggestion of a human gesture. The rough, exterior surface of the casts, not the interior of the molds, intrigued him. It was almost as if the gestures might be obscured if other details were rendered too carefully. Then he noticed that the interior surfaces of the casts captured evidence of life in incredible detail, and that these were amazing in their own right. Later still, he observed the changes taking place in his own face. The details he noticed were of the aging process. I understood his term "middle aging" to include both the interior and exterior changes that occur.

By this time, I had already completed my first photograph, and George, who was doing most of the talking, had settled into an easy chair. More than an hour had passed. George still had more to say.

As of late, he had been making portrait drawings in this studio using charcoals. With him sitting in that easy chair by the window, I could see why. The windows to his chicken coop let in a strong, low and raking light transverse to the interior space. Dark, shadowy lines proliferated across his face in a way that would be difficult for white plaster to capture. Black charcoal on white paper clearly would be more faithful to what I saw. While flattery was never one of George's artistic concerns, the light in his studio was unsympathetic to the natural creases in our faces. I think that it was his family and friends that George was drawing with charcoal, but, interestingly, he seemed to be drawing himself, too: they looked like him. Seeing him with his work reminded me of my own mortality, and I wondered if that thought had not crossed George's mind, as well.

Photographing PAT KECK

I felt uneasily lulled by the idyllic setting that led to Pat Keck's house in the Massachusetts woods. Neatly paved, winding roads passed by grazing horses and through a leafy forest up to her driveway. When I saw the trimmed landscaping, I began to worry. This was dangerously normal.

Pat herself struck me as "regular" as regular people come. She invited *p90* my assistant and me into her two-room workshop where all the tools were tidily in their places. The rooms were small, like an efficiency studio, with some finished sculptures on display and others, partly assembled, still in production. "Automatons," she called them, puppet-like sculptures that are internally powered to move limbs, fingers, mouths and even eyes. A hidden, servo-electric motor silently brought the figures to life. While most people may conjure up innocent or playful images when they think of a puppet, these automatons were sinister. Creepy. She must have sensed our discomfort. That's when Pat laughed her gleeful laugh.

We scattered her half-made sculptures across the floor. She put on a Klaus Nomi CD and the rooms filled with his wailing falsetto. We talked about Divine, John Waters, and other fringe artists. I asked her to pick up the chainsaw that she uses to rough out her carvings and stand in the midst of our manufactured chaos.

Finally, I could make her portrait.

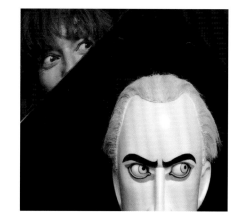

Pat Keck with The Watchman

Photographing LUIS JIMENEZ

I photographed Luis Jimenez at his home in Hondo, New Mexico. Luis grew up in a rough, urban, working class neighborhood in El Paso, Texas. He lost the vision of his left eye as a young boy when shot with a BB gun. His father was a sign maker and Luis worked in his shop. As a teenager, Luis helped fabricate a large sheet metal rooster commissioned for a roadside diner. With changing fortunes the rooster was sold and relocated several times, eventually landing on a perch over a bowling alley. Years later, Luis found the rooster and installed it in the courtyard outside his front door where it stands today.

I felt a connection between the literal, forceful nature of the rooster and Luis' sculpture. He wants the meaning of his art to be recognized upon sight by the working man on the street. Just like those enormous glasses suspended outside opticians' doors, or the giant cones stuck on top of ice cream parlors, the rooster reflects a communal sensibility. The rooster, in its original context, sent an honest, unpretentious message about the diner's enterprise. Luis uses this type of language to express a Latino perspective of the American experience. His brightly painted, fiberglass sculptures are made with the tools and materials found in automobile body repair shops. The sculpted muscles of his figures emphasize physical labor, sexuality coats their glossy surface, and life's struggle is a recurring theme.

At the time I visited him, Luis was working on a commission for the p76 Denver International Airport. This sculpture is a monumental rearing horse. The horse was inspired by Black Jack, an Appaloosa stallion Luis recently bought.

My close-up portrait of Luis was made with the Denver stallion's head, in clay, behind him to suggest scale. Luis is an intense man, and as we talked, his presence overwhelmed that of the horse. I moved in closer, making *him* progressively more monumental, all the while expecting to be told to back off. I framed the composition so tight that his face didn't even fit into my viewfinder. I later

Luis Jimenez with Black Jack and rooster

blackened out the horse, abandoning any sense of discretion along with my original intent. The portrait became a monumental study of Luis' face. Even before I developed the film, I was certain that he would find this image too revealing and that I'd have to choose another for this book.

Luis Jimenez demonstrates in his work that he has the courage to not avert his eyes when he is looking for the truth. He speaks plainly, with conviction, and shows us what he sees. I think it is a measure of Luis' integrity that, upon seeing the proofs, the close up portrait is the one he encouraged me to use.

Photographing CHAKAIA BOOKER

p32

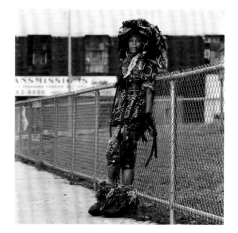

My experience with Chakaia Booker was perplexing because, as much as I wanted to address her art, other issues arose at her doorstep that I could not ignore. I knew from our earliest phone conversations that Chakaia was reticent and uncomfortable in front of a camera. That was a familiar challenge. What I was not prepared for was the extraordinarily bold, visually striking figure she cut and how this would unnerve me.

Frankly, I was stunned when Chakaia opened the door of her studio off 133rd Street in New York. I'm a slight man at 5'8" and towering over me was a cool, black face draped in several yards of colorful cloth whose dark brown eyes sized me up without expression. *"This is the way I always dress,"* she said.

What does one do in such a situation? I hadn't even crossed the threshold. Was it impolite to comment on her fabulous appearance or was it worse to pretend that nothing was out of the ordinary? I chose to notice. Much of our ensuing conversation had to do with the way that she dressed. I felt a need to understand it before I could begin to think about shooting an honest portrait.

Chakaia Booker in New York City

Only later did I realize that Chakaia's height was enhanced by thick-soled shoes and a turban. It was especially the turban which created the towering impression. It added significantly to her height. She makes all of her own clothes, these from an African textile. Yes, people on the street notice. *"I've learned to not walk by schools at the time they let out."* Yes, she often faces the consequences of strangers' judgments. *"There is a difference between a person and her appearance."* And, I eventually came to conclude, her dress served a very useful purpose. It sorted out people who are satisfied with superficial judgments from others who are open to learning about things they don't already know.

The more we talked, the more similarities we found in our experience. It became easier for me to see beyond how differently she dressed to how beautiful she was. There was a temptation to invoke the fashion sensibility in her portrait, but fashion wasn't really Chakaia's concern. Instead, I chose an image that captured her smile, printed it on fabric, and bunched up the cloth to preserve for her a refuge should any viewer's stare be too harsh.

Photographing VLADIMIR KANEVSKY

Vladimir Kanevsky makes whimsical ceramic figures whose simplicity belie their sophistication. He invites both myth and personal history into his work. The two blend to provide a quirky context and imply a multitude of tales that might be told. After visiting in the kitchen over strong, Russian coffee, we made our first portrait in his library. We were supervised by a most curious cat, one we could not help but include. Then we searched for what else we might try.

It so happens that the single snowstorm of the 1997-1998 winter fell on the day that we met. I asked my new friend to select a sculpture we could bring outside. He chose a ceramic figure who had been hovering prone, twelve inches above the tabletop, and lifted the piece to his shoulder. We went to a nearby park

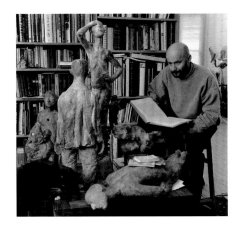

Vladimir Kanevsky with cat

p94

144

and Vladimir stepped into the snowy field. There, holding only part of a single work, Vladimir quietly invited fresh interpretation of the familiar vista using nothing more than his innate ability to tell a story.

Photographing MAGDALENA ABAKANOWICZ

Magdalena Abakanowicz' sculpture addresses the inexplicable tolerance with which society has accepted a repression of the individual spirit.

I spoke only twice to her as she toured the sculpture park. One time I asked her to pause so I could photograph her on a hilltop where her sculpture would be installed. She agreed, then raised her arms to suggest the height of the bronze piece. When she did this the bottom of her jacket flared out, creating a triangle with her head at the apex, and this shape lent unexpected interest to the composition. I included this image in my Grounds For Sculpture exhibit the following year. The second time I spoke was at the end of her visit, just before she left. I asked permission to photograph her from a closer distance. She smiled, held her glasses in her hand and leaned her head back to catch more of the sunlight. A gentle breeze lifted her hair just as I clicked the shutter. I knew then that I had made a second significant photograph.

Two years after I photographed her, I reexamined this close-up in my darkroom. I found it to present a strong, self-assured and composed, elegant woman. She basked in the warm rays of an autumn day's light with a beatific smile. Her central position within the image and the shallow focus of the background emphasized her importance. It was a flattering photograph. Because of her celebrity status, it would undoubtedly be well received in the media. For me, however, this image was a frustrating burden. It was too good to set aside, yet I could not reconcile such a celebrity portrait with the visceral force she invests in her work.

Magdalena Abakanowicz on hilltop

p18, 134

I tried printing this negative yet another time. I made a print and studied it still wet in the water bath. I suspected that different enlarger settings might afford an improvement but, rather than expose an entire sheet of paper, I elected to use only a small test strip and find out. I exposed and processed the test strip. When I got to the water bath, I laid the still wet test strip over the first print for a direct comparison. At this point I could closely examine the two prints in room light.

I was searching for very specific, tonal distinctions when something unexpected caught my eye. The image of the test strip was aligned with that of the print beneath – both the left and right shoulder lines matched, her face seemed appropriately placed and her hair blended in – yet somehow something was offset. It took only a moment for me to realize the blessing bestowed by this chance event.

I fully processed both the test strip and the large print, then dry mounted the two exactly as I had first seen them when wet. This composite image still shows Magdalena Abakanowicz to be a strong and gracious woman. For me, though, with her personal features surviving an intrusive displacement, this photograph tapped into visceral forces and became a much more relevant portrait.

Photographing PHILIP GRAUSMAN

There is an interesting twist in my relationship with Philip Grausman and his work: our passions intersected long before we actually met. When I received my first assignment to photograph a foundry, in 1992, his monumental bust, *Leucantha*, was about to be cast. It figured prominently in many pictures of the casting process that I made for the client. The finished sculpture was installed at Grounds For Sculpture and, for a time, my photographs of this work were among the most widely published images of the park.

Seven years later, just outside the entrance of the DeCordova Museum in Massachusetts, I came upon a fiberglass head just like the one I had pho-

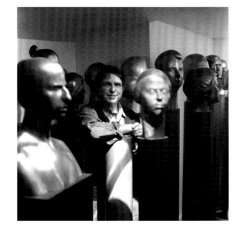

Philip Grausman in his studio

tographed at the foundry. It was like meeting an old friend, although I had yet to meet Philip Grausman. Soon after, I arranged to photograph him at his home in *p12* Connecticut.

The simple, decisive elegance that figures so prominently in Philip's work is also evident in his home and studio environment. There is ample breathing space between the various areas where he develops different facets of his work. Walking from one area to another permits an unrushed savoring of the experience just completed, and it also cleanses one's palette for the new impressions about to be made

What I learned the day of our portrait session was that I had come across Philip's work in my childhood. There, in his Connecticut studio, was a large, copper grasshopper, quite unlike the heads that he is now best known for. It was a substantially older piece, and I recognized it immediately – it was the first sculpture I ever photographed. I had photographed it at an art gallery on Newbury Street in Boston, while on a field trip with my photography class in the eighth grade. My memory of this is clear because I was scolded by the owner for taking pictures in her gallery. Even though the old grasshopper negative has since been discarded, its image remains etched in my memory.

I smile now to think that a childhood scolding helped me remember an artwork, and that more than thirty years later, the artist who created it still provokes me to explore the world with a camera.

Grasshopper, 1968, by Philip Grausman.
Copper and brass, 68" long

My foray into the portraiture of sculptors has been especially rewarding because it affirmed for me the unbounded potential of the human spirit. Each of the sculptors I met had embarked on a lifelong search for meaning using materials and experiences commonplace to their lives. The artwork they produced nearly always challenged my expectations, forcing me to reevaluate ideas I thought I understood. I was allowed to see the temporary scaffolding that these artists built to bridge concepts and make their progression of small steps to the finished piece possible. Ultimately, I discovered, their finished work was an expression of identity.

Not all artworks are immediately accessible, nor are their makers. An investment is often required to open their meaning. I found that portraiture can create opportunities for such understanding. Simply having a face, even a gesture, to associate with an artwork provides a human connection, a subtle opening that we can use to explore what the artist is trying to say. Portraiture can even stimulate new ideas that may support or extend the artist's intent.

The sculptors I met are very much like the rest of us. They continually face choices and make small-scale decisions that address an immediate need. In resolving their problems they, too, find that the simplest solutions generally work best.

What makes these particular sculptors so notable is the way in which they address uncertainty. Rather than settle for safety, they respond to the question *"What if?"* with curiosity, courage, and vision. In so doing, they show us that life's richest possibilities are drawn from the realm of what was previously unknown.

Artists need not be strangers. I'd like to think my portraits help bring them closer to home.

RB

On Finding Sculptors
and Their Artwork

FROM THE OUTSET, THE PURPOSE OF THIS BOOK HAS BEEN TO SAMPLE AND celebrate diversity in the approaches of contemporary sculptors to their work. My resources allowed for me to find and include only so many artists; there are many, many more fine sculptors working in the field today than I could possibly photograph. Within the context of an overwhelming selection, I stand firmly by my choices. These are interesting artists involved with interesting work. We will be rewarded if we lend them our attention. They hint at the nature and breadth of contemporary sculpture today.

My roster must not be construed to be exclusive. You will find that the word "greatest" appears only once in this book – in this very sentence. This is relevant because even a few words of media hype can act like poison dropped into a well. Hyperbolic critical reviews harm the artistic community far more than they benefit the individual receiving the praise. Artists, good artists, are all around us. You'll probably find two or three sculptors behind that bush in your own backyard.

The artists I found were certainly scattered behind lots of back yards. Their neighbors knew them by their first names. Caution is advised for those who would use this book as a field guide. With my book in hand, someone looking for Barry might overlook Annee. Or they may not take Sal seriously because he wasn't included. I'd much prefer that my book serve as an appetizer; I hope that it cultivates a desire to personally find and see art, as well as to meet new artists and to learn their stories.

A good place to start on a search for interesting sculptors is your nearby sculpture park. The International Sculpture Center lists over one-hundred-twenty sculpture parks scattered throughout thirty-eight states in the United States alone. Sculpture parks that I've been able to visit so far include Grounds For Sculpture in New Jersey, Storm King and Socrates Sculpture Park, both in New York, the DeCordova Museum in Massachusetts, Fairmont Park in Pennsylvania, the Hirshorn Museum in Washington, D.C., The Navy Pier Walk, in Illinois, and Franconia Sculpture Park, in Minnesota. Interesting sculptors can be found through professional associations. These include: The International Sculpture Society, based in New Jersey; The National Sculpture Society and the Sculptor's Guild, both based in New York; and the Washington Sculptors Group, based in Washington, D.C. The International Sculpture Center publishes Sculpture Magazine, which has an international distribution, as does The Sculpture Review, published by the National Sculpture Society. All of these organizations have a presence on the Internet.

Finding specific sculptures can be tricky. Few sculptural installations are truly permanent, and the vast majority of artworks in museum collections rotate between storage and display. Thus they are not always available for viewing. Works in private collections may be inaccessible without a personal introduction. Fortunately, artists often have sister pieces in their studios, so I recommend that you start your own adventure with them. Many have web sites; their addresses are listed on the following pages.

And, as you search for sculptors, don't forget to look behind that bush!

SELECTED WEB RESOURCES

Night Flight, 1996
by Vladimir Kanevsky.
Stoneware, encaustics, wood
14 x 32 x 6"

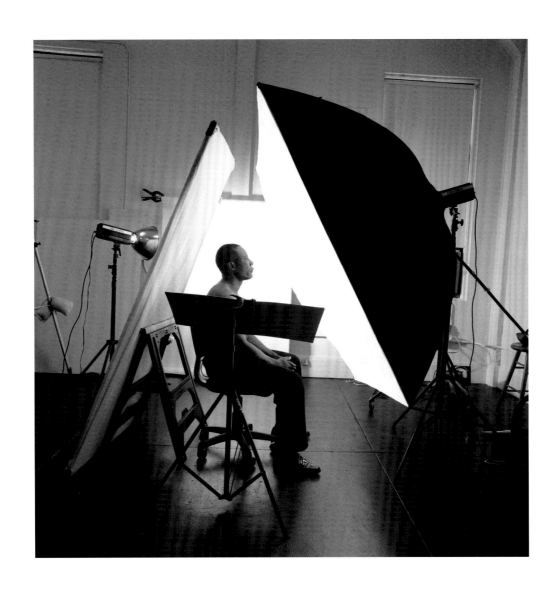

Joseph Acquah in my studio

TECHNICAL NOTES

ON AVERAGE, EACH OF THE PHOTOGRAPHIC SESSIONS LEADING TO ONE OF these portraits lasted approximately four hours. Occasionally the sessions were longer, and some finished in as little as fifteen minutes. The portraits were made with Kodak TMax 100 Black and White film, a Hasselblad camera and, most often, a short focal length lens that pulled me close to my subject. I regularly use strobes and reflectors to control ambient lighting. Although these may be invisible in the final presentation, my subjects typically saw an assistant, light stands, extension cords and so many equipment cases that it was sometimes difficult to walk among them.

The photographic experience is by no means complete once film has been exposed. In fact, the print making process teems with opportunity for unexpected discovery. For seven of the thirteen portraits listed below, the photograph's final form was conceived in the darkroom.

In addition to traditional silver prints, my tool kit also includes optical, chemical and digital image manipulation, hand coated emulsions, and carbon pigment digital prints. I experiment freely upon the slightest provocation. No one technique is better than another, although for any particular image one may be the more appropriate choice.

The original photographs represented by this book are either traditional, silver chloride prints, iris prints, or carbon pigment digital prints. When similar versions are available in both silver and carbon pigment, I prefer the latter. In fact, as of early 2002 I have been making carbon pigment digital prints almost exclusively.

TECHNICAL NOTES, *continued*

Philip Grausman, *p13*
silver print, conventional wet darkroom processing. Isolation effect achieved on-site with artificially lit, white foamcore.

Peter Lundberg, *p15*
silver print conventional wet darkroom processing. Isolation effect achieved with darkroom masking.

Magdalena Abakanowicz, *p19*
silver print, conventional wet darkroom processing. Test strip dry mounted onto print surface.

Chakaia Booker, *p33*
photo emulsion hand coated onto fabric.

Charles Ginnever, *p35*
silver print, conventional wet darkroom processing. Two negatives optically blended at enlarger.

Helena Lukášová, *p37*
silver print, conventional wet darkroom processing. Torn paper negatives, destructive bleach bath and redevelopment to produce a silver monoprint.

Niki Ketchman, *p47*
original film (negative) scanned, image selectively erased in PhotoShop, carbon pigment digital print.

Joseph Acquah, *p57*
silver print, conventional wet darkroom processing. Three negatives optically blended at enlarger.

Robert Lobe, *p89*
facial impression made with tin foil and pinned to tree.

Vladimir Kanevsky, *p95*
it snowed.

Bill Barrett, *p109*
original film (negative) scanned, tonal scale selectively reversed, carbon pigment digital print.

John Goodyear, *p113*
silver print, conventional wet darkroom processing. Two negatives optically blended at enlarger.

Martha Posner, *p131*
silver print, conventional wet darkroom processing. Destructive bleach bath and sponged redevelopment to produce a silver monoprint. Monoprint scanned, Iris print output.

What really matters, though, is the final result.

Carlos Dorrien through his kitchen window and working on *Unveiled Justice*

Turtle Lady, 1998
by Charles Wells.
Ash
38 x 29 x 11"

ACKNOWLEDGEMENTS

THIS BOOK IS THE MOST RECENT EXAMPLE OF HOW MY WORLD HAS BECOME richer by allowing other people into my life. It would not exist were it not for the gifts that colleagues – friends both old and new – have presented me with. They gave me their time, their honesty, and their truths. They invested their hope, trust, and beliefs. They gave me what I needed and more; it is all in this book. Any accomplishments of this project are as much their success as they are mine.

First, a sincere thank you to the sculptors themselves. I have profound respect and admiration for every one whom I was able to photograph. I hope to do them justice. I'd like to also thank the curators who helped me find them: Brooke Barrie, Director of Grounds For Sculpture; Nick Capasso, Curator of the DeCordova Museum and Sculpture Park; Gwen Pier, Director of the National Sculpture Society; and Marsha Child, of Marsha Child Contemporary.

Operating on a shoestring budget, this project was dependent upon family and friends for logistical support. Thank you for the bed, board, and more to: Cel and Ralph Hess, Suzana Lisanti, Peter Kaplan, Christina and Jeff Kramer, Eileen Hohmuth, Michael Lemonick, Michael Burke and Linda Pilkinton. Four individuals, each in their own way, served as catalysts to the evolution of this book. They took the time to sort through my puzzle pieces and help me realize that none were missing. Thank you to Ian Summers, Michael A. Smith, Paula Chamlee, and Nancy Brokaw.

Production assistance came with the help and example set by Nancy Ukai Russell, Kate Winton, Kathleen Forsythe, Marianne Nelson, Jon Naar, and Markus Wiener. Unsung heroes are my assistants: Nicholas DiPietro, Jonathan

Timmes, Kelly Hoffer, Mike Casserly, and Nelson Carlson. I can't imagine what this book would be like if not for the contribution of these professionals. I never want to leave home without them.

I'm also grateful for the support I received the good, old-fashioned way. Bru and Chuck Katzenbach, Cathy Knight, Don Denny, Ruth Boulet and Bill Kerins helped sustain both this project and my spirits. I'm also thankful to the Johnson & Johnson Corporation for their support, as well as that from The Fogg Art Museum, the Philadelphia Museum of Art, and the Free Library of Philadelphia.

And yet none of this would have been possible without the support of my wife, Heather, who managed both of our responsibilities whenever I abandoned mine for the sake of this book. I'm in awe of her patience upon my every return, allowing me to develop all of my film that very same night. And, after twenty-five years, I still look forward to our engaging review of discoveries at the end of each day.

Thank you, one and all.

Credits

Lyrical excerpt from "Asking Too Much" (p vii) written by Ani DiFranco, © Righteous Babe Music. All rights reserved. Used by permission.

All photographs by Ricardo Barros, unless otherwise noted. Page x, Pat Keck; p14, Peter Lundberg; p20, Rico Eastman; p22, Caroline Gibson; p32, Nelson Tejada; p38, Bill Botzow; p50, Sydney Blum; p54, Joel Breger; p58, Nick Merrick/Hedrich Blessing; p60, Cel Hess; p64, John Hock; p66, James Beirne; p76, Luis Jimenez; p78, Beckett Logan (digitally altered); p80, Karl Stirner; p82, Wojtek Naczas; p84, Courtesy of John Michael Kohler Arts Center, Collection of Stephen and Pamela Hootkin; p86, Beverly Burbank; p90, Pat Keck; p94, Peter Gritsyk; p98, Todd Giegg; p110, Ken Hruby; p116, Konstantin Simun; p118, Courtesy Charles Cowles Gallery; p126, Arthur Ganson; p130, Larry Fink; p147, Collection of the Mattatuck Museum; p153, Peter Gritsyk; p158, Charles Wells; p164, Larry Fink.

All works © their respective authors.

Sculptors on page 132, from top left: Coral Lambert and Jim Brenner, Thom Cooney Crawford, Richard Heinrich, Yongjin Han, Charles Colburn, Larry Steele, Barry Parker, Joel Perlman, le Corbeau, Joseph Eisenhauer, Andrew Dunnill, David Hostetler, Don Bonham, Harold Tovish, Jon Isherwood, Strong-Cuevas, John Newman, Julie Bruening, Larry Fane, Jean Humke.

Nick Capasso and Ricardo Barros at the DeCordova
Museum. Bill Botzow's *Bemoth* in rear.

162

ABOUT THE AUTHORS

RICARDO BARROS is a professional photographer. He has been the principal photographer at Grounds For Sculpture in Hamilton, New Jersey, since 1992, his photographs regularly appear in Sculpture Magazine, and he has produced exhibition monographs for many sculptors including Marisol, Magdalena Abakanowicz, Red Grooms and Dale Chihuly. Barros' own work is included in the permanent collections of: The Smithsonian American Art Museum; the Philadelphia Museum of Art; Harvard University's Fogg Art Museum; the DeCordova Museum; Grounds For Sculpture; the New Jersey State Museum; The Museum of Art of São Paulo, in Brazil; The Museum of Image and Sound, also in Brazil; the Ellarslie Museum; En Foco, Inc.; the Free Library of Philadelphia; the Newark Public Library; and the Johnson & Johnson Corporate Collection. Barros is represented by Marsha Child Contemporary, in Princeton, New Jersey, and his studio is located in Morrisville, Pennsylvania. On line he can be reached through www.ricardobarros.com.

NICK CAPASSO, PhD, is the Curator at the DeCordova Museum and Sculpture Park in Lincoln, Massachusetts. He has fifteen years experience as a curator, critic and art historian of contemporary American art. The works he has presented range from the photography of Edward Steichen to works by contemporary sculptors and video artists. He writes for Sculpture Magazine and is the author of "Bones of the Earth," a book on John Van Alstine's sculpture.

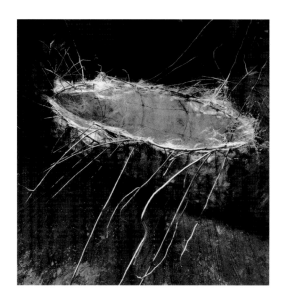

Boat for a Night's Journey, 1999
by Martha Posner.
Fabric, beeswax, fencing, rose canes,
rope, synthetic hair
59 x 166 x 100"